IMAGES
of America

GREYSTONE PARK
PSYCHIATRIC HOSPITAL

IMAGES
of America

GREYSTONE PARK
PSYCHIATRIC HOSPITAL

Rusty Tagliareni and Christina Mathews
Introduction by Robert Kirkbride

ARCADIA
PUBLISHING

Published by Arcadia Publishing
Charleston, South Carolina

Printed in the United States of America

Library of Congress Control Number: 2015955296

For all general information, please contact Arcadia Publishing:
Telephone 843-853-2070
Fax 843-853-0044
E-mail sales@arcadiapublishing.com
For customer service and orders:
Toll-Free 1-888-313-2665

Visit us on the Internet at www.arcadiapublishing.com

To all who lived and died at Greystone.

*To those who fought so tirelessly to save it from destruction, and
to those who continue to ensure that it will never be forgotten.*

CONTENTS

ACKNOWLEDGMENTS

Through the years we spent recording the story of Greystone, we met countless wonderful people. As time progressed and we came to tackle the crafting of this book, these newfound friends became invaluable assets. Simply put, this book would not exist without the tremendous support we have received from everyone who wishes to see Greystone remembered.

Of particular note are the ever-welcoming staff of the Morris Plains Museum, the North Jersey History Center at the Morristown and Morris Township Library and their archive of rare photographs from 1899, Pete Olin and his incredible image collection, Jody Johnson for capturing the entirety of the demolition process via aerial photography, the *Daily Record* for ensuring that Greystone news was always kept in the public eye, and Mark Moran of *Weird NJ*, who has been instrumental in helping us to navigate through the incredible turbulence that was Greystone's final years.

Unless otherwise noted, all images appear courtesy of the authors.

There was much more to Greystone than just brick and mortar. By its fall, the old hospital on its hilltop in Parsippany, New Jersey, had come to be representative of an entire era of mental health care, from the unparalleled humanitarian efforts of Dorothea Dix to the revolutionary architectural concepts spawned from the mind of Thomas Story Kirkbride. Unfortunately, at the end of its life, the asylum had also come to be a grim reminder of neglect and abuse. Through this, Greystone embodied a rare kind of historical and societal significance; it became a single building that represented both the brightest and darkest of humanity's efforts with, and perspective toward, those who cannot care for themselves.

Though Greystone's physical form has since been razed from this earth, in its final moments, the old hospital became a martyr for a greater cause. It seemed that, as Greystone's walls fell, people once again were able to see the derelict asylum for what it was, for what it was intended to be, and not what it had become. As the dust settled, a deep sense of loss hung over the community. What was special about Greystone, however, was that these feelings did not simply impact the minds and hearts of the New Jersey residents who had known the old asylum—they echoed outward across the nation, effecting those who had never before seen the building in person. People across the country followed Greystone during its final years, updated regularly through the news and online media. Because of this, the asylum's loss was universally affecting, and across the United States, communities with their own Kirkbride asylums began to look upon them with renewed respect and with the collective mindset of "lets not allow this to become another Greystone."

Greystone lives on not only in these pages, but also in the historic asylums across the country that found salvation through its demise. It is our sincere hope that this book may be used not only as a history lesson, but also as a preservation tool.

INTRODUCTION

Give me your tired, your poor, your huddled masses yearning to breathe free.
—Emma Lazarus

In the eyes of the world, 1876 was an auspicious year for the United States of America. Despite economic tensions and the aftermath of a war that had divided the nation, a bright symbol of the country's rise—the torch of the Statue of Liberty—was exhibited in Philadelphia at the first international exposition held in the United States, and it remained for several years after in New York City's Madison Square Park. Conceived as a memorial to the nation's abolition of slavery and its first century of independence, the colossus would inspire the immortal words from Emma Lazarus and was kindred in spirit to another monumental structure completed in the same year, not far away.

On October 31, 1876, managers of the State Hospital for the Insane at Morristown, New Jersey, submitted the first annual report for a vast new building shaped by similar egalitarian ideals. The founding managers wrote that Greystone Park Psychiatric Hospital, as it would later be known, "will ever remain as a monument to the enlightened liberality of the age and the State that gave it existence."

If only those aspirational words had proven to be true.

The cover of this book shows Greystone Park Psychiatric Hospital in mourning for a simple reason. Despite public outcry and the committed resilience of local citizens, Greystone was unceremoniously demolished across the summer of 2015. With no plausible explanation, state officials disregarded multiple offers for redevelopment—including at least one at no cost to taxpayers—and turned an indifferent eye to due legal process by accelerating demolition, which eliminated the option of federal funding for preservation. Even as New York State refurbished H.H. Richardson's Buffalo State Asylum for the Insane, New Jersey taxpayers' money was directed by state leadership to erase a structure of national and global significance.

There are complex and conflicting views toward the preservation or destruction of Kirkbride hospitals. Embracing this complexity is critical to the imaginative reuse of these immense structures, which average hundreds of thousands of square feet and offer remarkable examples of architectural know-how, embodying energy and memory, personal and communal. They also offer remarkable opportunity.

Some may see only horror in these buildings, and in asylums in general, and this is understandable. Although they were conceived under the Enlightenment belief in the therapeutic powers of beauty, and despite the ideals of the Kirkbride Plan to provide a place of care for the placeless, the asylums offer cautionary reminders of the frailties of human infrastructures and bureaucratization in the name of efficiency.

Challenging as it may be, it is important to decouple the Kirkbride hospitals from the sensationalized associations that have accumulated around them. When Thomas Story Kirkbride urged superintendents to know the names of all of their patients, he established a critical scale for optimal performance. Each stagger-step of a Kirkbride Plan Hospital was designed for a manageable cohort, yet that did not deter the mental health system from overpopulating these structures

almost immediately. As noted in the first annual report, Greystone could "easily accommodate eight hundred patients, with the necessary officers and attendants," but it was not designed for the thousands it hosted at any given moment in its long history.

Except for their first few years of operation, most Kirkbride hospitals never had an opportunity to operate at the scale of peak effectiveness. Administrators, physicians, and caretakers were compelled into a perpetual mode of crisis management, exacerbated by the traumas of economic depressions and frequent wars.

Overuse was not the fault of the asylums themselves. The buildings did not commit people; people committed people. Yet too often, these buildings have been treated as scapegoats by politicians and others whose petty vendettas and short-term interests distract the public from tending mindfully to the bones of our public infrastructure and addressing the clear and present neglect of our national mental health care.

Buildings like Greystone accumulate dense histories, inspiring mixed sentiments that are easily overlooked in favor of a single coherent narrative. Yet there is no single, omniscient history; there are coexisting truths and crosscurrent histories, unfolding from vantages that often differ and are dynamic. Careful, thorough readings of primary sources—the original artifacts and buildings—cultivate empathy for the past and present. Thoughtful site documentation, historical research, physical restoration, and adaptive reuse promote continuity across generations, sustaining cultural memory and identity, as Tom Mayes has emphasized in a series of articles written recently for the National Trust for Historic Preservation. Such reasoning demonstrates with crystalline clarity why old buildings, especially buildings such as the Kirkbrides, matter.

Greystone represented a vast amount of embodied energy—the resources expended in the building's fabrication in all its financial, material, and human facets. These include the infrastructures necessary to build the building, including quarries and worker housing, along with power, water, and material supply. Of course, buildings are more than the sum of matter and energy; they represent our embodied intelligence. Human imagination—and lack thereof—manifests itself through our constructed environment. How we make is how we think. Human know-how and belief systems are embodied in the details that appoint our everyday lives. Such details are easily overlooked but subconsciously furnish our imaginations, equipping us to be and become ourselves. Like all Kirkbride hospitals, Greystone represented a commitment to enhanced mental wellbeing through a beautiful and well-designed environment.

Akin to other Kirkbrides, Greystone was built by standards now hailed as economically and environmentally sustainable, with materials quarried close by and appointed with local help in the stained-glass, mechanical systems, and furnishings that were later influenced by Gustav Stickley's Craftsman Farms, a national historic landmark just three miles away. With unbridled pride and optimism, the first annual report informs New Jersey citizens:

> The provision here made for the care and cure of the insane is most ample in extent and excellent in character, and is fitting evidence of the humanity and liberality of the State towards its insane citizens, who are, in an especial sense from their helpless condition, its own proper wards. . . . The facilities of such an establishment when well organized and in working condition are *immeasurably* superior to any that can be supplied by friends or by city or county authorities, and therefore should be availed of in behalf of all those who, through the loss of reason, are entitled to its benefits.

Kirkbride hospitals are among our nation's most compelling social innovations, providing shelter for the unfortunate as part of the broader public good and a more level playing field for the pursuit of happiness as an inalienable right. Destruction of such products of human care and skill, willful or not, is not merely wasteful; it is hubristic and nonsensical.

Study of the demolished Kirkbrides benefits from urban explorers and documentarians who have captured details of these structures before their disappearance. Rusty Tagliareni and Christina Mathews have made substantial contributions through their project Antiquity Echoes, and such photographic

and documentary projects as *Greystone's Last Stand*. These materials are invaluable to support digital documentation and virtual reconstructions. Yet, as I have learned from my own multimedia research on two Renaissance memory chambers, the true value of such media is to stimulate curiosity and point us to the actual artifact. Such documentary efforts may enhance, but can never replace the original artifact. Primary sources are far superior to digital reconstructions, regardless of rationale.

Why? Human learning is multisensorial, experiential, and contextual. Buildings offer ideal vehicles for cultural and personal narratives. The architecture chosen by our founders to represent our fledgling nation, less than four score years prior to Dr. Thomas Story Kirkbride's influential treatise on asylum keeping, is part of an ancient legacy informed by the arts of rhetoric and activated by public debate and shared governance. The list of formidable architects who designed Kirkbrides, including Samuel Sloan, H.H. Richardson, and Thomas U. Walter to name a few, are of a lineage that extends back through Thomas Jefferson, Andrea Palladio, and Leon Battista Alberti to the *res publica* of ancient Rome and the *polis* of Athens.

Democracies and the public forum call for architecture whose decorum and ornament offer memorable locations, aesthetically and cognitively speaking. Such locations furnish public debate with perches for the "birds of thought," whose flight powers the private and public imagination, instilling civic pride and shared identity. The chapel and amusement room offered two such locations at the heart of Greystone and the Kirkbride Plan. In a 1981 article, George Layne described Thomas Story Kirkbride's groundbreaking use of photography and the magic lantern in psychiatric therapy, a practice called out by Greystone's managers:

> [The amusement room is] fifty-nine by forty-seven feet, and twenty-four feet high, is well lighted, and is to be fitted up with stage and scenery for tableaux and minor theatrical representations on one side, and with arrangements for showing magic lantern views on the other. The spectators are furnished with seats with reversible backs. The chapel is seventy-one by thirty-seven feet, and thirty-six feet high, and is lighted by stained glass windows. The arched wood ceiling is embellished with stencil work, and the sides, front end (a plain surface) and rear end (an arched recess) are tastefully frescoed. Both of these rooms are exceedingly valuable for the purposes for which they are intended, and are now in frequent use.

No longer. Despite national rallies and formal legal efforts to stay demolition, officials at every level of New Jersey government, including those who understandably yet regrettably remained silent as events unfolded, could not see the value of revitalizing this remarkable piece of human history. When transparent exchange is denied and buildings constructed for the public good are deliberately erased without remorse, swift and tenacious response is necessary to lend voice to the silenced and support due process.

Local communities are embracing the complexity of the Kirkbride hospitals, increasingly aware of their long-term, multifaceted value. Enthusiasts are fascinated with the daunting logistics of building one of these vast structures at a time prior to motorized construction equipment. They are committed to the challenges of resuscitating the hospitals for a range of new uses and for those as-yet unimagined. Such negotiations are the blessings and burdens of democracy.

The Statue of Liberty has been revitalized on several occasions by the generosity of our citizens. If only that had been possible for Greystone, whose ignominious fate represents an epic failure of our collective imagination and a cautionary tale of the consequences of nontransparent and wasteful governance. We have been denied an opportunity to remake a resource created to help others remake themselves. We were also denied an opportunity to re-envision our own future through the lens of a Greystone transformed.

It is my sincere hope, and of others I represent, that Greystone Park Psychiatric Hospital and its tens of thousands of physicians, staff, and patients, including those who died while in residence, are duly respected and memorialized with the salvaged remains of the building to ensure that Greystone, although erased, is not forgotten.

—Robert Kirkbride

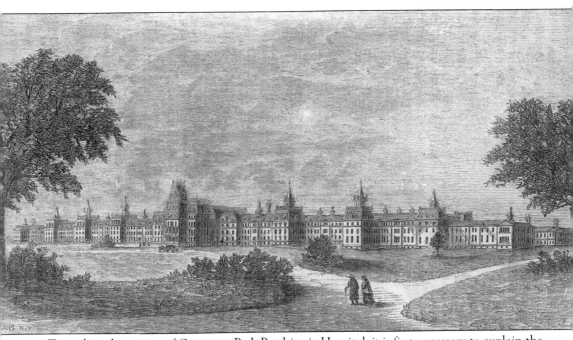

To explain the origins of Greystone Park Psychiatric Hospital, it is first necessary to explain the ideals behind its creation. Greystone was built around a plan that adhered to the principles of Thomas Story Kirkbride. Thomas Kirkbride was first and foremost a psychiatrist, but what he will forever be remembered for was his advocacy for the mentally ill. He devised a plan of building that, in its very form, could serve as a therapeutic tool to aid in the recovery of patients who benefited simply by being present within its walls. Abundant sunlight and copious amounts of fresh air were key principles of his, along with the view that patients, no matter how afflicted, should never be treated as anything less than respected human beings. His concept came to be called the Kirkbride Plan, and over 60 massive asylums were built throughout the nation based upon its premise. Of all these facilities, none matched the size or scope of Greystone Park, the largest Kirkbride Plan institution to ever exist. (Courtesy of Mike McDevitt.)

One

GREYSTONE RISES

If not for Dorothea Dix, the American asylum system as we know it would not exist. Before her efforts, the mentally handicapped often lived out their lives in poorhouses, warehoused in prisons, or worse. During the mid-1800s, Dix traveled extensively, documenting the living conditions of mentally handicapped individuals in poverty. The end result of her years of work was the Bill for the Benefit of the Indigent Insane, which was to set aside 12,225,000 acres of federal land "for the benefit of the insane." Additionally, proceeds were to be distributed to the states to erect and maintain asylums on these properties. Though the bill passed both houses of Congress in 1854, it was vetoed by Pres. Franklin Pierce. Regardless, the bill helped usher in an era of mental health care reform in the United States, which in turn resulted in the construction of many asylums throughout the country. To this day, the Bill for the Benefit of the Indigent Insane is considered a landmark in social welfare legislation, and Dorothea Dix a pioneer in the advocacy of the mentally handicapped. (Courtesy of the Morris Plains Museum.)

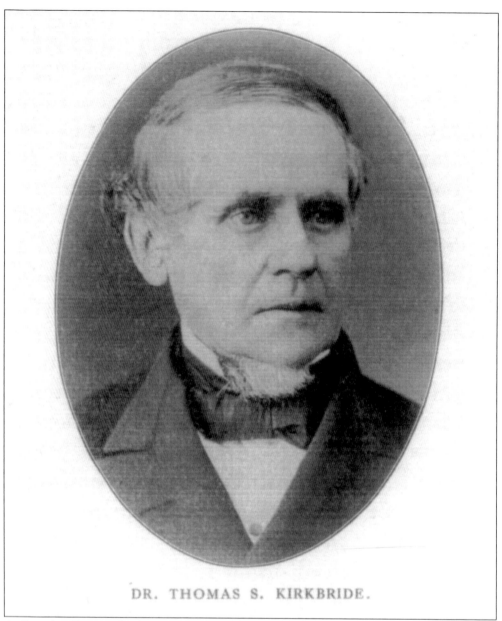

DR. THOMAS S. KIRKBRIDE.

As Dorothea Dix was the driving force behind the foundation of an asylum system for the United States, Thomas Story Kirkbride in essence perfected the art of their construction. With a heavy focus on compassion and the therapeutic properties of nature, Dr. Kirkbride went about devising a plan of buildings that embraced these ideals. Hospitals built to these specifications came to be known as "Kirkbride Plan" asylums, the hallmark of their construction being two massive wings outstretching from a central body. Plentiful windows overlooking bucolic settings allowed ample sunlight and fresh air to penetrate the asylums. Beautiful fixtures and furniture were also seen as essential. Thomas Kirkbride himself said, "There is no reason why an individual who has the misfortune to become insane, should, on that account, be deprived of any comfort or even luxury." (Courtesy of the Morris Plains Museum.)

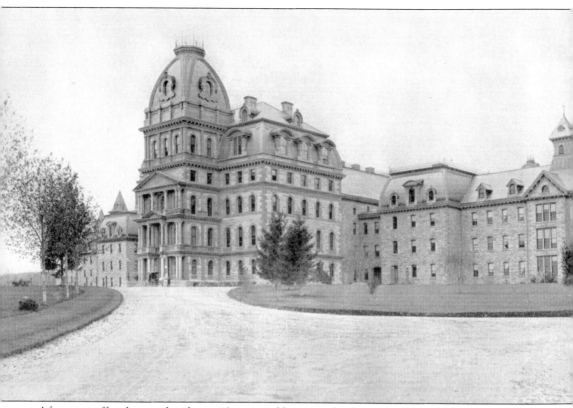

After state officials considered over 40 potential locations for the construction of the state's second psychiatric hospital, a hilltop just outside Morristown in what is now Parsippany, New Jersey, was chosen as the ideal place. The building was designed by renowned architect Samuel Sloan, who had previously worked on such projects as the Eastern State Penitentiary in Philadelphia and the famous Longwood mansion in Mississippi. With all of the hospital's stonework quarried on the premises, the asylum was quite literally raised out of the earth upon which it stood. Greystone opened its doors on August 17, 1876. The new asylum was originally known simply as State Asylum for the Insane. The name "Greystone" did not come around until many years later, derived from the ashen-colored gneiss stone from which it was constructed. Greystone eventually became the asylum's official moniker in 1924. (Courtesy of the Morris Plains Museum.)

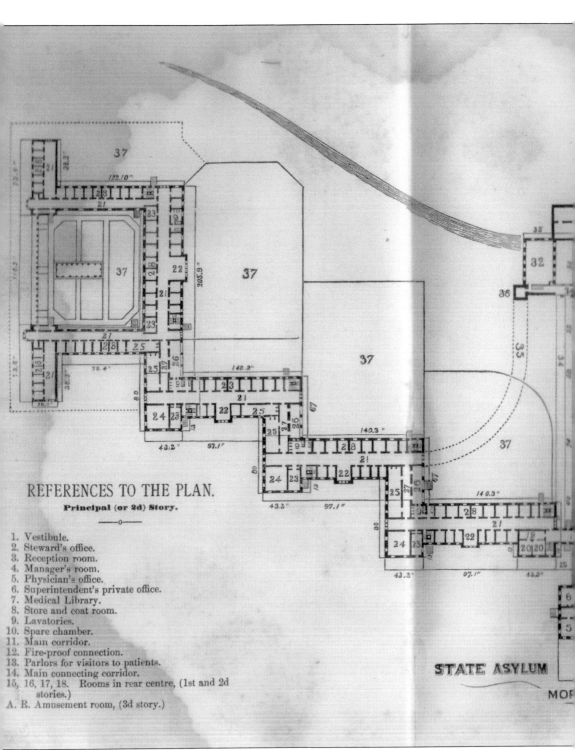

REFERENCES TO THE PLAN.

Principal (or 2d) Story.

——o——

1. Vestibule.
2. Steward's office.
3. Reception room.
4. Manager's room.
5. Physician's office.
6. Superintendent's private office.
7. Medical Library.
8. Store and coat room.
9. Lavatories.
10. Spare chamber.
11. Main corridor.
12. Fire-proof connection.
13. Parlors for visitors to patients.
14. Main connecting corridor.
15, 16, 17, 18. Rooms in rear centre, (1st and 2d
 stories.)
A. R. Amusement room, (3d story.)

STATE ASYLUM

MOR

Greystone's floor plan, as illustrated in this foldout diagram from the hospital's 1878 annual report, gives a detailed view of not only the complex workings of the hospital, but also a sense of its massive size. At 673,700 square feet, all built on a single foundation, the asylum dwarfed any

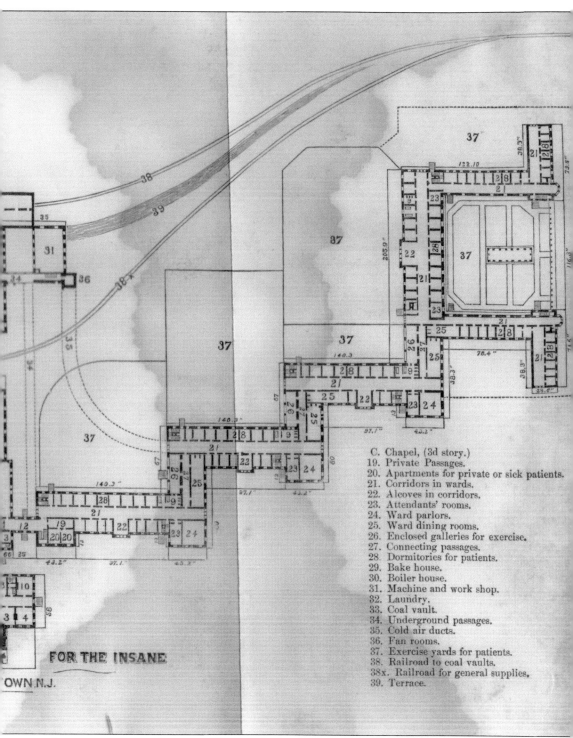

C. Chapel, (3d story.)
19. Private Passages.
20. Apartments for private or sick patients.
21. Corridors in wards.
22. Alcoves in corridors.
23. Attendants' rooms.
24. Ward parlors.
25. Ward dining rooms.
26. Enclosed galleries for exercise.
27. Connecting passages.
28. Dormitories for patients.
29. Bake house.
30. Boiler house.
31. Machine and work shop.
32. Laundry.
33. Coal vault.
34. Underground passages.
35. Cold air ducts.
36. Fan rooms.
37. Exercise yards for patients.
38. Railroad to coal vaults.
38x. Railroad for general supplies.
39. Terrace.

FOR THE INSANE

OWN N.J.

other construction in the nation. It was only decades later, after the completion of the Pentagon in Arlington County, Virginia, that Greystone lost its title as the largest continuous-foundation building in the country. (Courtesy of the Morris Plains Museum.)

Greystone's first annual report was submitted a mere two and a half months after opening. Beyond the fact that the hospital was already housing well over 300 patients (most of whom were transferred from the state's other asylum, the severely overwhelmed Trenton Psychiatric Hospital), the report also informs that "considering the great size of the building, the durable character of the material of which it is composed, and the careful workmanship on the walls and interior finish, it may be truly said that it has scarcely an equal certainly no superior in these respects, in the world." (Both, courtesy of the Morris Plains Museum.)

FIRST

ANNUAL REPORT

OF THE

SUPERINTENDENT

OF THE

STATE ASYLUM FOR THE INSANE,

FROM THE OPENING OF THE INSTITUTION,

AUGUST 17, TO CLOSE OF YEAR, OCTOBER 31, 1876.

TO THE MANAGERS OF THE ASYLUM.

GENTLEMEN:—In compliance with the law for organizing this Asylum the Superintendent submits to your board, his

FIRST ANNUAL REPORT.

The Asylum was opened for the admission of patients on the 17th of August, 1876. From that date until the 31st of October, inclusive, the close of the fiscal and statistical year, there have been admitted three hundred and forty-six patients.

	Men.	Women.	Total.
Received To Nov. 1st, 1876	161	185	346
Discharged recovered	1	1	2
Discharged improved		1	1
Died	1		1
	2	2	4
Remaining Oct. 31st, 1876	159	183	342

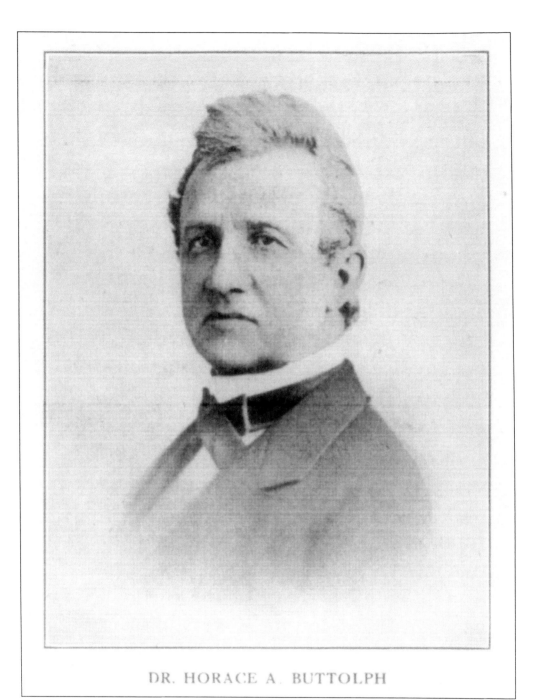

DR. HORACE A. BUTTOLPH

Dr. Horace A. Buttolph was initially the superintendent at Trenton Psychiatric Hospital before circumstances placed him elsewhere. When the state of New Jersey set about planning the construction of its second asylum, Dr. Buttolph was selected as a member of a small team tasked with scouting out the most suitable location. In 1872, the hilltop in Parsippany, which was suggested by Dr. Buttolph, was selected as the most ideal location. Just one month before Greystone's completion, he was appointed the first superintendent. He served in that position until his retirement on January 1, 1885. (Courtesy of the Morris Plains Museum.)

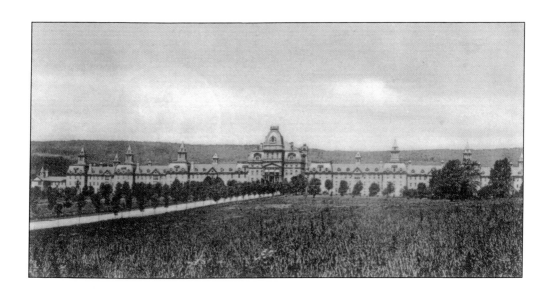

The Greystone Park Psychiatric Hospital opened its doors in 1876. Situated upon some 740 acres, the ornately appointed hospital and beautifully landscaped property that surrounded it quickly became an attraction for people from far and wide to see for themselves. Picnicking on the grounds was encouraged, and numerous postcards were printed of the hospital, often focusing upon its iconic front facade and domed roof, as is the case with these early 1900s postcards, which guests could purchase as mementos or to mail home to family and friends. (Both, courtesy of the Morris Plains Museum.)

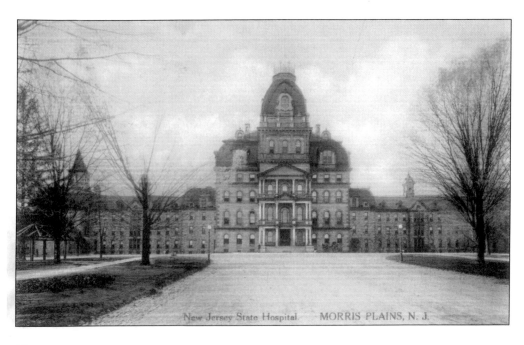

New Jersey State Hospital. MORRIS PLAINS, N. J.

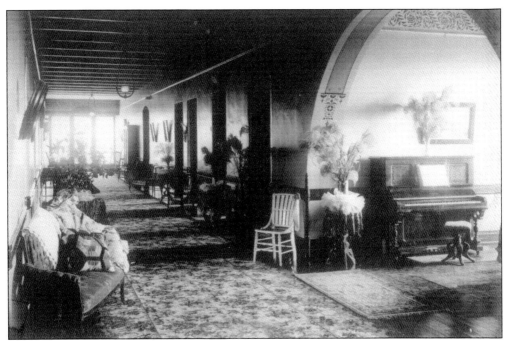

As detailed as the exterior of the hospital was, it paled in comparison to the craftsmanship found within Greystone's walls. This turn-of-the-century photograph of the women's ward shows to what lengths the hospital went to ensure a comfortable environment for patients. It was paramount that the people living within Greystone never felt trapped there; rather, it was the intention that those who required long residency feel as if they were experiencing a stay at a resort or health clinic. Even the bars used to retain patients were often ornately designed. In many instances, patients could even bring their own furniture, which allowed them to feel more at home and provided a sense of comfort and familiarity when adjusting to asylum life. (Both, courtesy of the Morris Plains Museum.)

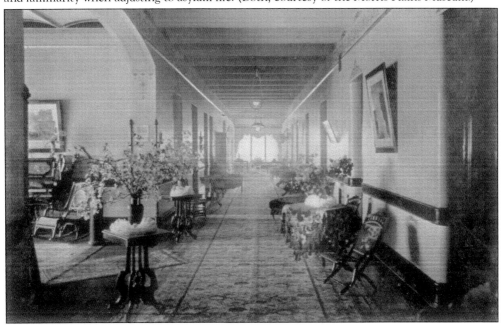

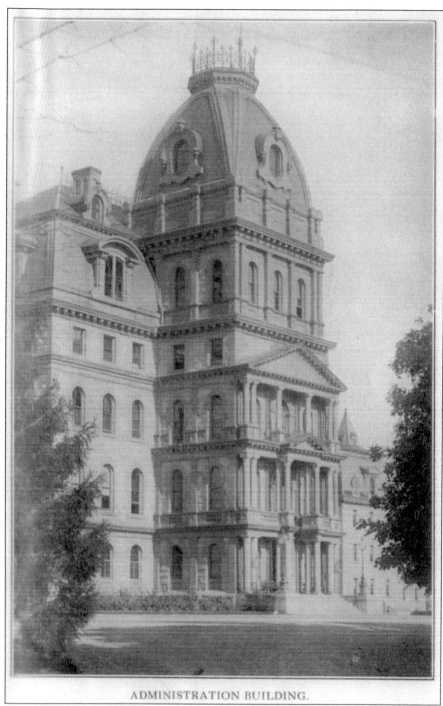

ADMINISTRATION BUILDING.

The "Administration Building" was one of numerous titles given to the central portion of the Greystone asylum, from which stretched the tremendous wings of wards. Even though it was indeed a connected portion of the greater whole that was the asylum, due to the scope of the facility, it was still labeled as if it were a separate structure. At times, this part of the building was also called Center Main or the Central Administrative Offices. (Courtesy of the Morris Plains Museum.)

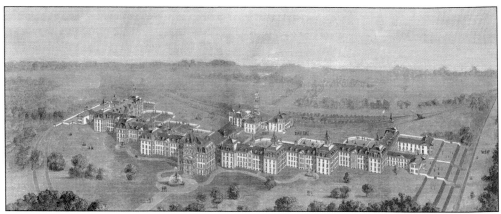

This bird's-eye view of the hospital from 1878 allows for a much better understanding of the building's layout than could ever be gleaned from ground level. As per the Kirkbride Plan, each outstretched wing contained wards of patients, with the more violent ones housed farther away from the center. Rows of large windows on every floor, coupled with the hospital being orientated to face toward the east, allowed the rooms and halls to be filled with the maximum amount of sunlight. The wings also separated patients by sex. Male patients were housed in the northern wards (right side in this image) and females were kept in the southern wards (left side). (Courtesy of Preserve Greystone.)

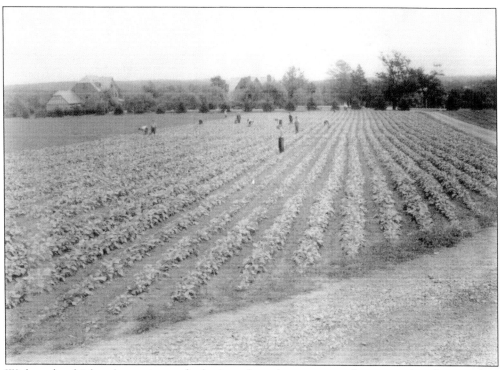

With such a high value put upon fresh air and sunshine, a major focus was placed on outdoor activities for the patients. Since the facility was built around a model of self-sufficiency, these activities often served a greater good for the hospital as a whole. Here, patients are tending to crops in one of Greystone's many fields in the summer of 1902. (Courtesy of the Morris Plains Museum.)

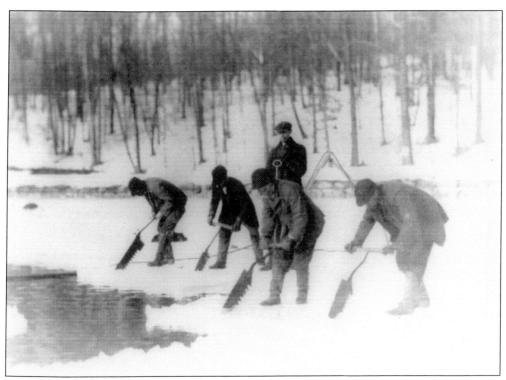

Ice was harvested at Greystone's pond. Hand and horse-drawn blades carved out large chunks from the frozen surface. These pieces were then loaded onto a conveyor belt and stored within the icehouse on the bank of the pond. Before refrigeration was available, the ice from this pond was instrumental for use in the hospital. The tip of Greystone's northernmost wing can be seen up the hill to the right below. (Both, courtesy of the Morris Plains Museum.)

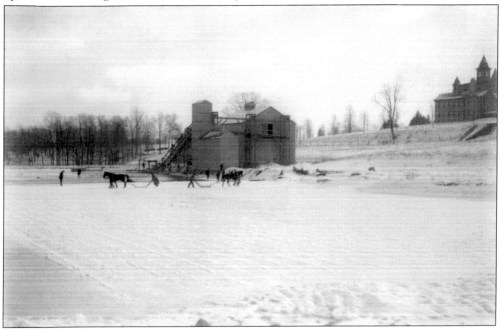

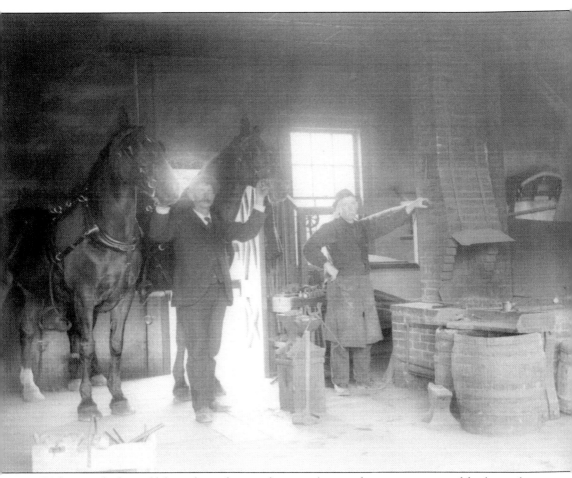

With so much physical labor taking place on the grounds, many horses were required for day-to-day operations at the hospital. Their jobs ranged from working plows to transporting goods, and even pulling carts for Greystone's own fire department. Horses were very important to life at Greystone, and thus it was necessary that they receive proper care at all times. Pictured is a tack room with a blacksmith standing next to his firing pit. (Courtesy of the Morris Plains Museum.)

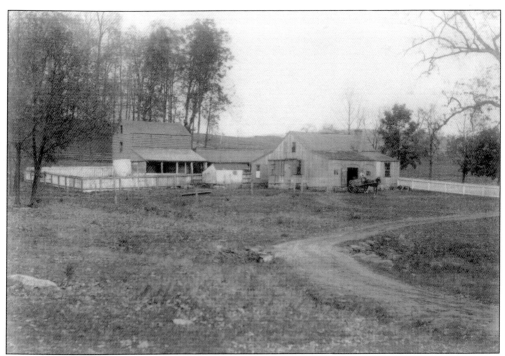

Stables and various other farm-related outbuildings dotted the Greystone property. The photograph above shows the old asylum slaughterhouse, which was destroyed in a fire in 1918. Below, a portion of the asylum dairy farm is pictured. Though part of a bustling mental health complex, these simple, rustic buildings looked similar to structures found on the open plains of the Midwest. (Both, courtesy of the Morris Plains Museum.)

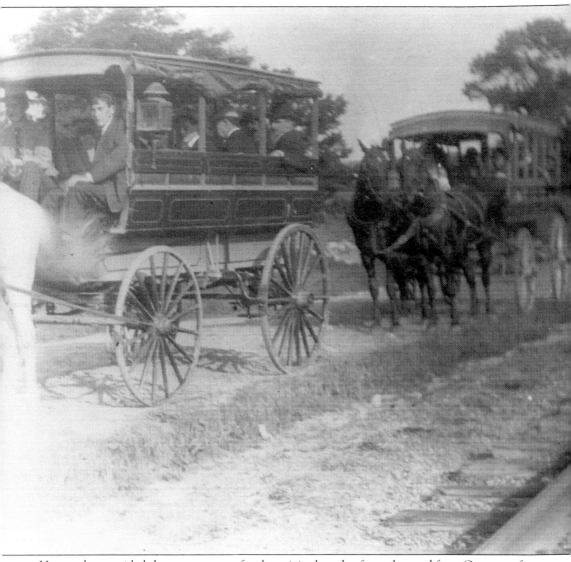

Horses also provided the power source for the original mode of travel to and from Greystone for the outlying communities. Horse-drawn carriages were used for the transportation of patients and visitors from the day the hospital opened in 1876 until 1909, when a rail trolley system replaced them. (Courtesy of the Morris Plains Museum.)

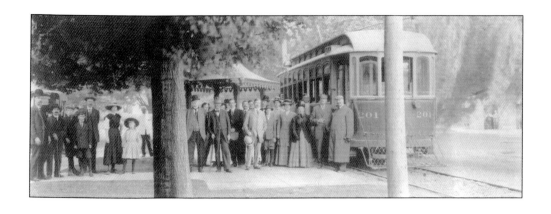

A modern trolley system, running on rails, provided not only a much faster travel time for passengers, but also had a far higher capacity for travelers than the horse-drawn carriages allowed. The image below captures the first day of service for the original asylum trolley. (Both, courtesy of the Morris Plains Museum.)

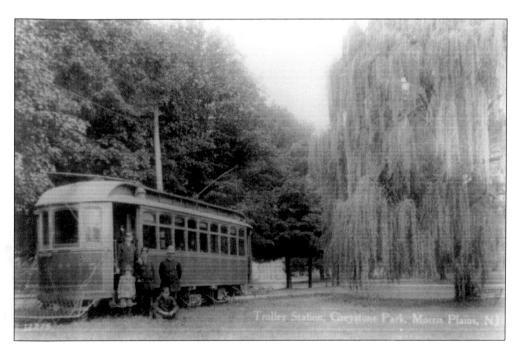

Trolley Station, Greystone Park, Morris Plains, NJ

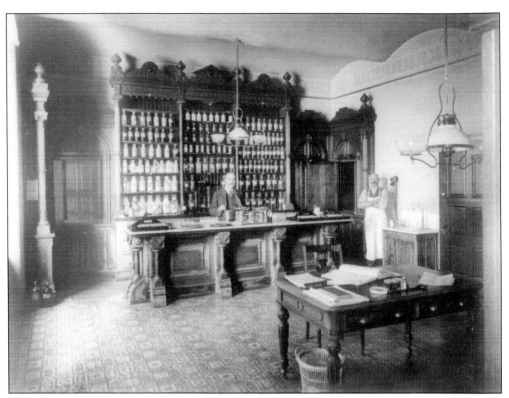

The Greystone pharmacy is pictured in 1916. There was an intense attention to detail in everything constructed for the hospital, and the pharmacy was no exception. Every piece of wood, iron, or stone that made its way into Greystone was carved and detailed, allowing the building to emanate an air of elegance and refinement, which in turn reinforced the hospital's sense of integrity with patients and their families. (Above, courtesy of the Morris Plains Museum; right, courtesy of Pete Olin.)

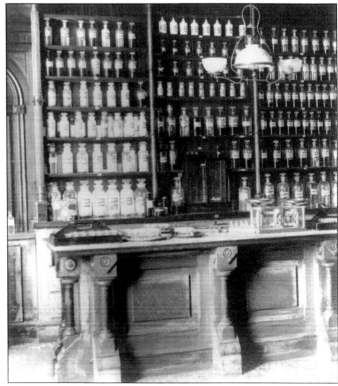

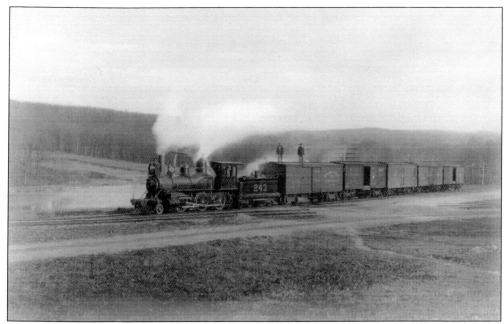

The railroad that once ran alongside what is now Old Dover Road was essential to the operations at the asylum. In fact, the presence of the existing railway was one of the deciding factors in Greystone's location. Though used for shipping and receiving goods, by far the most important role the railroad played was the delivery of coal. By 1917, Greystone was consuming over 70 tons of coal per day, using it to power the steam-heating system, gaslights, and the kitchens. (Both, courtesy of the Morris Plains Museum.)

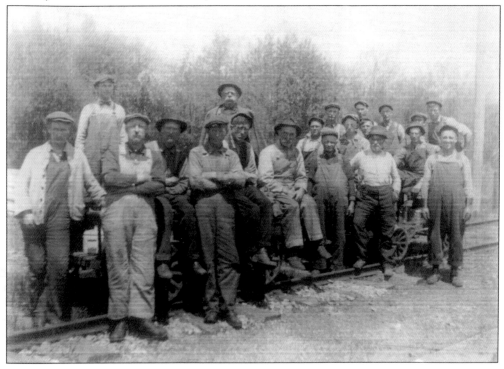

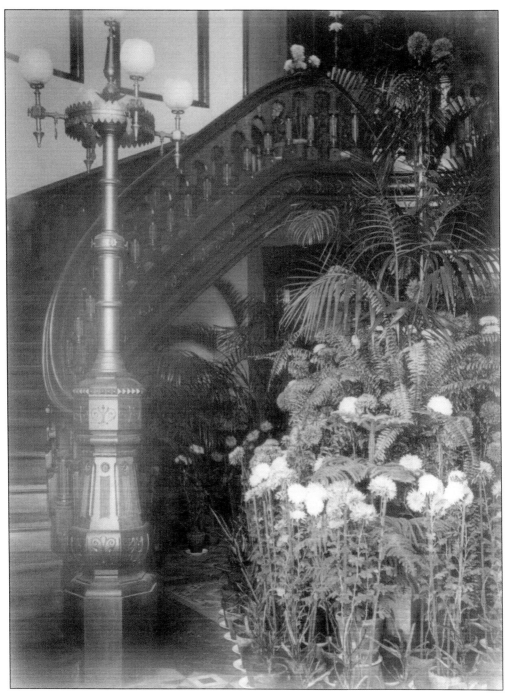

Flowers of all kinds were commonplace throughout the hospital. This was another feature that harkened back to the mindset of treatment wherein the therapeutic powers of nature were made available to the patients. Bringing in beautiful outside elements and making them regular fixtures helped to blur the lines between outdoors and indoors. Here, Greystone's master staircase is seen in 1902 adorned with a floral arrangement stretching nearly one story in height. (Courtesy of the Morris Plains Museum.)

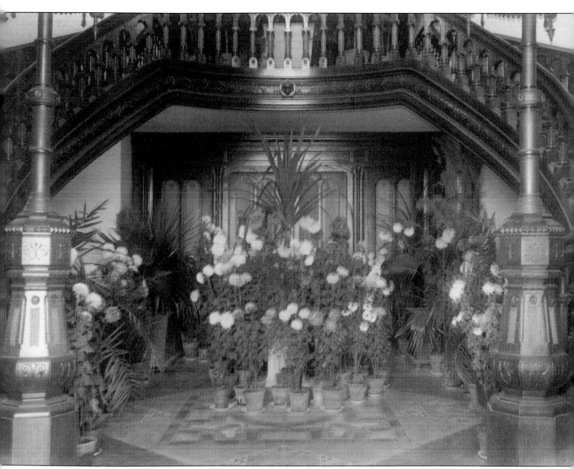

Here is another photograph of Greystone's master staircase and floral arrangements. These ornate wooden steps once graced the asylum's ground-floor lobby and granted access to the second floor. They were lost in a massive blaze in 1930, which claimed much of the building's decorative features. Unlike most of the asylum, this staircase was never reconstructed. (Courtesy of the collections of the North Jersey History Center, the Morristown and Morris Township Library.)

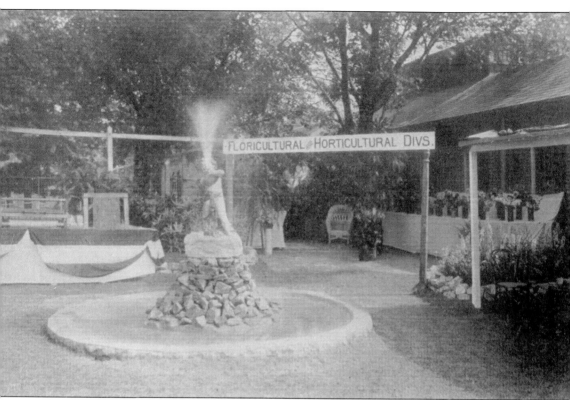

Given the high regard staff and patients had for flowers and ornate arrangements, it should come as no surprise that the Floricultural and Horticultural Division of Greystone's work-therapy program was among its most popular. Pictured here is a decorated display showcasing the work of the patients, complete with fountain. By 1916, the division had grown nearly 60,000 plants. (Courtesy of the Morris Plains Museum.)

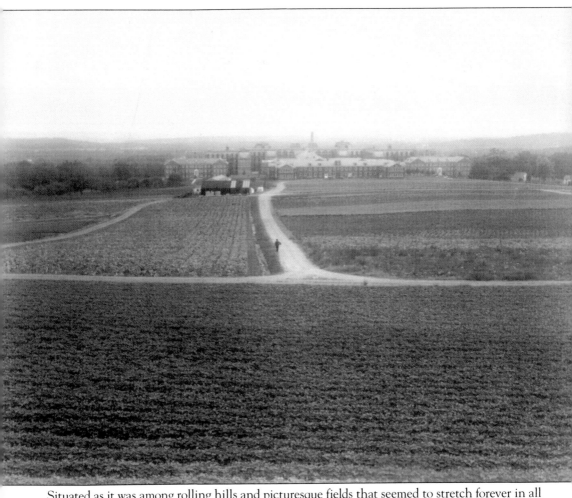

Situated as it was among rolling hills and picturesque fields that seemed to stretch forever in all directions, Greystone looked like an idealistic resort. It was dutifully fulfilling the purpose for which it was built, to provide the utmost care and compassion for those less fortunate, to be a safe haven for the destitute, and to be a beacon of hope to light the way into an era of modern psychological medicine—for a time, at least. (Courtesy of the Morris Plains Museum.)

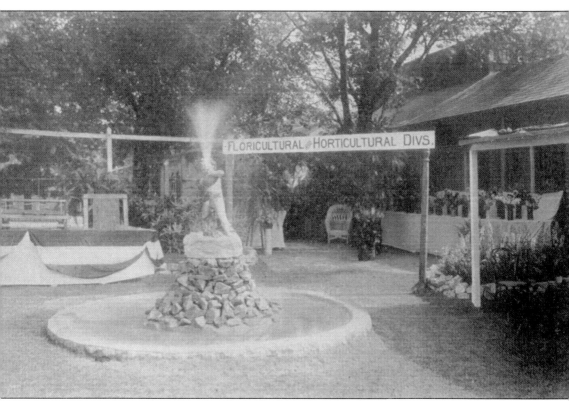

Given the high regard staff and patients had for flowers and ornate arrangements, it should come as no surprise that the Floricultural and Horticultural Division of Greystone's work-therapy program was among its most popular. Pictured here is a decorated display showcasing the work of the patients, complete with fountain. By 1916, the division had grown nearly 60,000 plants. (Courtesy of the Morris Plains Museum.)

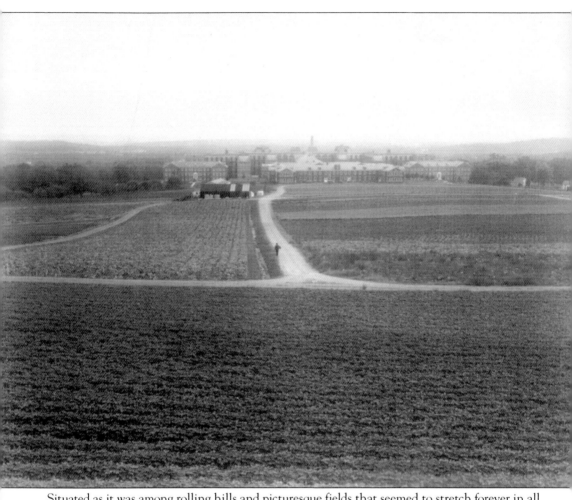

Situated as it was among rolling hills and picturesque fields that seemed to stretch forever in all directions, Greystone looked like an idealistic resort. It was dutifully fulfilling the purpose for which it was built, to provide the utmost care and compassion for those less fortunate, to be a safe haven for the destitute, and to be a beacon of hope to light the way into an era of modern psychological medicine—for a time, at least. (Courtesy of the Morris Plains Museum.)

Two

GROWING PAINS

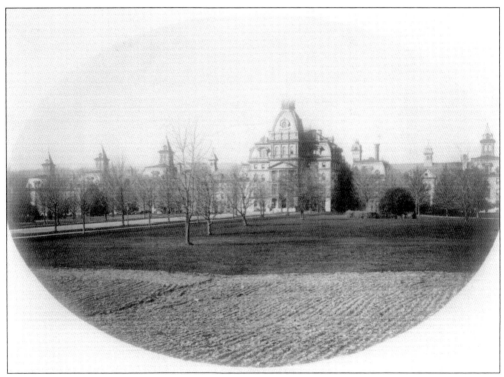

Not long before Greystone was constructed, the mentally handicapped were largely ignored and often shunned by society. Now Greystone stood proudly upon its knoll, valiantly correcting society's wrong in the noblest fashion possible. The trouble with such lofty ideas is that they can prove to be frail things. Often, it only takes a few small changes to a very precise system to derail an entire enterprise. This is not to say Greystone failed those who needed it, but it did suffer from many growing pains throughout its life, especially considering the patient influx it was experiencing just years into its operation. (Courtesy of the Morris Plains Museum.)

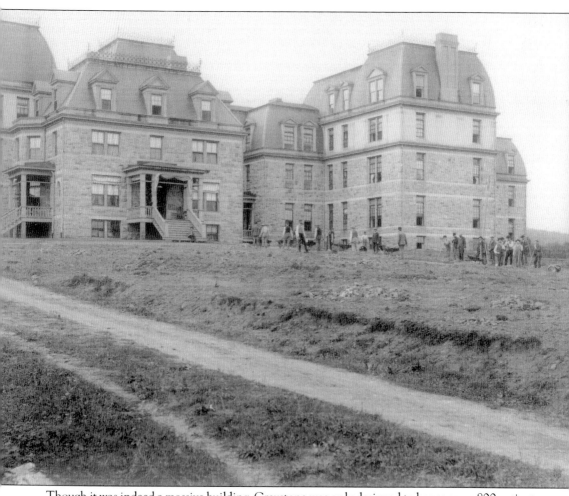

Though it was indeed a massive building, Greystone was only designed to house some 800 patients at any given time. By 1895, the number had swelled well beyond that to nearly 1,200. With an excess population of almost 50 percent, the asylum staff and the building were being pushed beyond their means. To help ease the overcrowded conditions, Greystone received funding from the State of New Jersey for the construction of a new building to be used for housing. This 1901 photograph shows the newly completed dormitory building. (Courtesy of the Morris Plains Museum.)

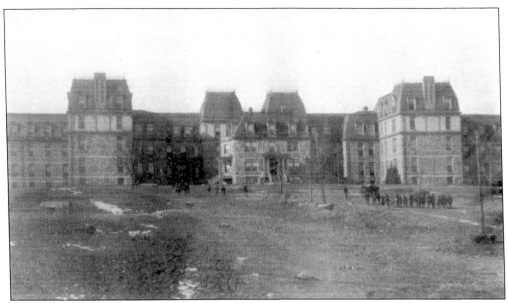

Like Greystone, the new dormitory building was designed in the Second Empire architectural style, which had fallen out of fashion by the 1880s. At the time of its construction, it was considered outdated. Due to this, the dormitory always appeared considerably older than it actually was. This image from 1909 shows workers grading the land surrounding the dormitory building. A proper driveway was later laid, which led directly to the front porch of the building. (Courtesy of the Morris Plains Museum.)

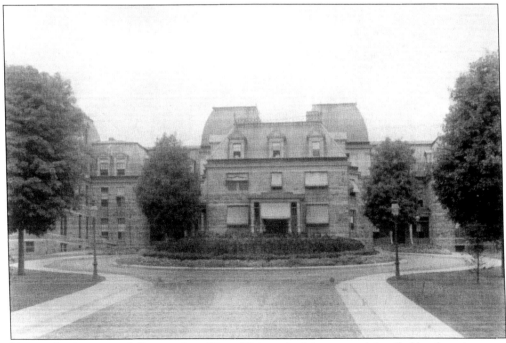

Here is the dormitory, fully complete. The addition of a driveway and detailed landscaping went a long way toward making the new building tie into the existing Greystone complex. (Courtesy of the Morris Plains Museum.)

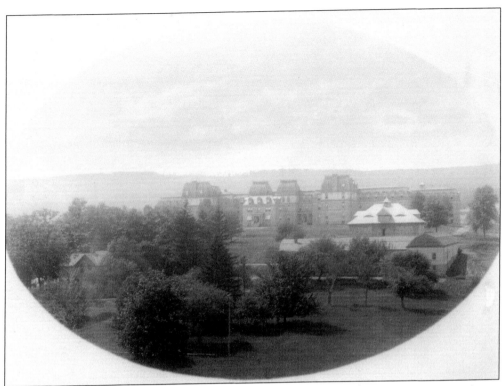

Above is a view of the dormitory from Greystone's roof. Below is the opposing perspective, a photograph of the back of Greystone. Though shot at different times, and very likely by different photographers, these images almost seem intended to be viewed together. (Both, courtesy of the Morris Plains Museum.)

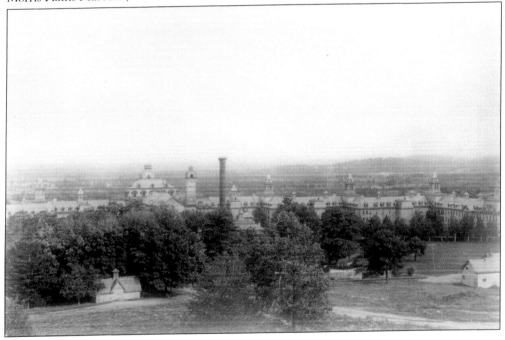

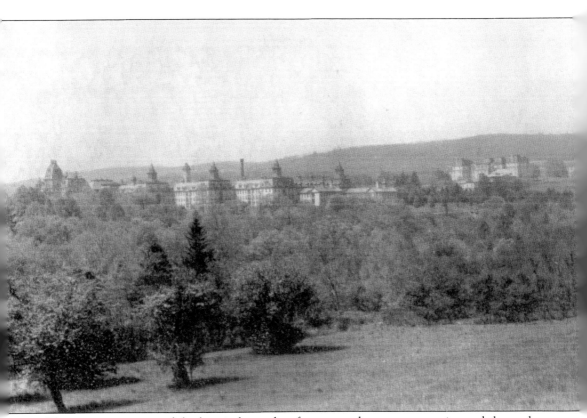

This panoramic view of the hospital was shot from a northern vantage point and shows the completed dormitory perched on its hill, situated behind the asylum proper. The dormitory was just one of many additional buildings that would eventually dot the landscape surrounding the original asylum. (Courtesy of the Morris Plains Museum.)

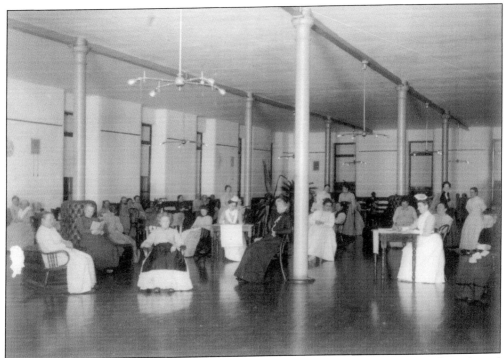

Mirroring the main asylum building, the new dormitory building featured winged wards and separated patients by sex. Pictured are the male and female sitting rooms. Both featured identical design and fixtures; however, as they were built on opposite sides of the building, their floor plans were mirrored. (Both, courtesy of the Morris Plains Museum.)

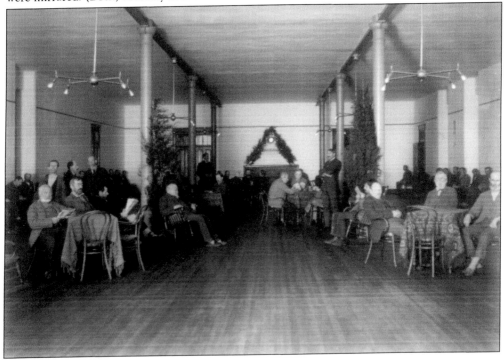

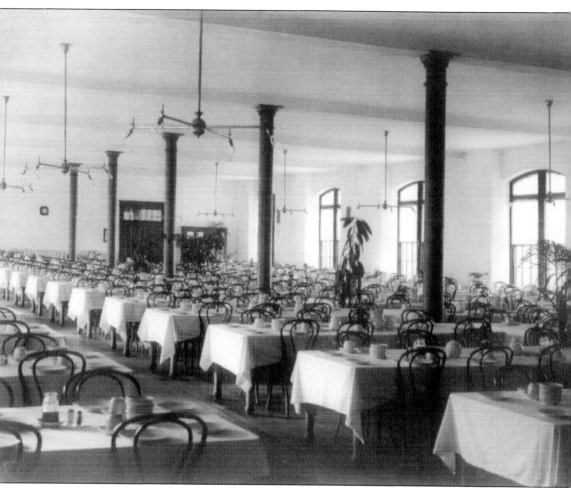

Like everything else at the asylum, the dining rooms at the dormitory were separated by sex. As can be seen in this 1917 photograph, every inch of usable space was utilized in the new building. Greystone was ever growing, and every patient needed to eat. Though tightly packed and considerably less ornate than the rooms found in the Kirkbride Plan building, great attention was still paid to cleanliness, and just as in the sitting rooms, live plants remained a regular fixture. (Courtesy of the Morris Plains Museum.)

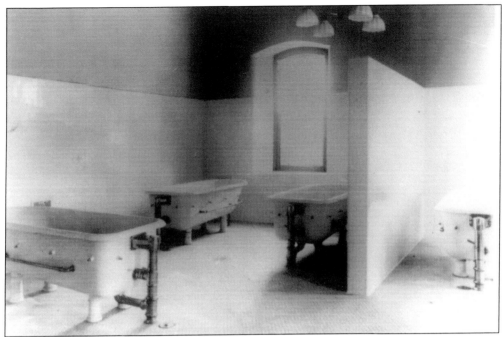

By 1907, the male and female wards of the dormitory building had operational hydrotherapy rooms. Patients were treated with variable pressures and temperatures of water (with extremes ranging from ice to steam), through baths and washes, in an attempt to help them regain their cognitive abilities. (Courtesy of the Morris Plains Museum.)

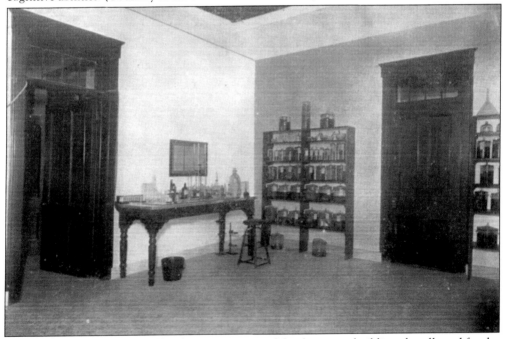

The additional room provided by the construction of the dormitory building also allowed for the expansion of the hospital's laboratory. Pictured is a single room of the newly completed laboratory annex. (Courtesy of Pete Olin.)

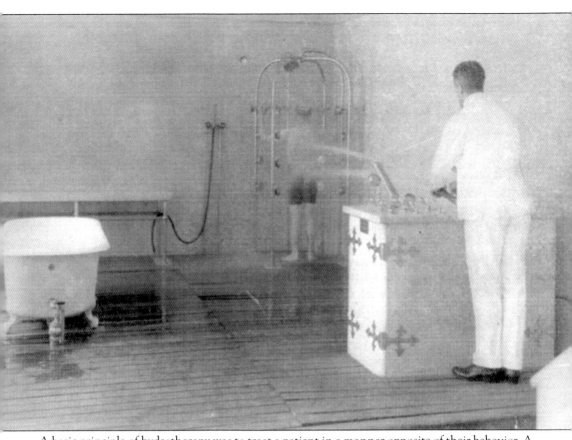

A basic principle of hydrotherapy was to treat a patient in a manner opposite of their behavior. A lethargic or inactive patient would be treated with vigorous water of either extreme temperature or high velocity (or both), as pictured here. If a patient were hyperactive, doctors would aim to sooth their behavior with warm, calming baths. (Courtesy of the Morris Plains Museum.)

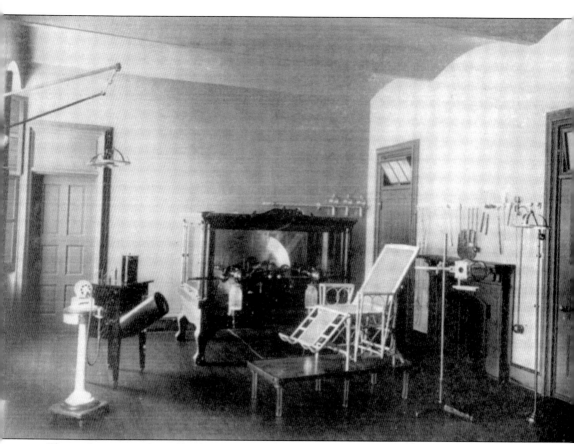

Electrotherapy, or electroshock treatment, was also very popular at Greystone. Here is one such treatment room in 1906, in the female ward of the dormitory building. Patients were strapped into a chair and had high voltages administered to their temples. Though today it is often seen as barbaric as originally practiced, its modern equivalent, electroconvulsive therapy, is used to treat severe depression. (Courtesy of Pete Olin.)

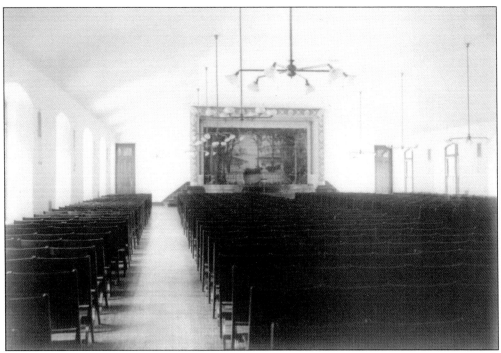

A theater was also built into the dormitory building, which provided entertainment and a way for patients (and staff) to escape from the overwhelming ordeals of life at an overpopulated mental asylum. The theater proved to be very popular and performances were a regular occurrence. Christmas plays and events became yearly staples. (Both, courtesy of the Morris Plains Museum.)

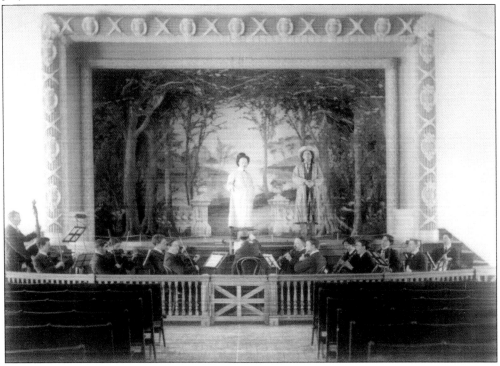

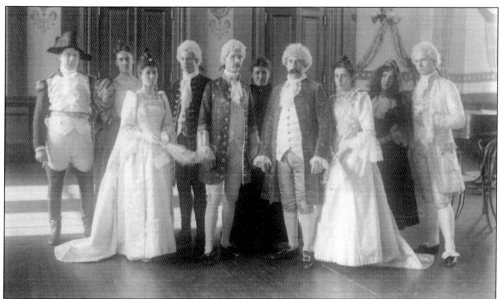

This photograph was taken during a fancy dress ball in 1899, one of many events at the hospital where patients and staff enjoyed constructive leisure time and music from Greystone's in-house musical talents. Activities such as there were commonplace, especially during the asylum's earlier years. Social events were seen as important to patients, as they allowed them to engage with other patients and staff in unique settings and circumstances, preparing them for life outside the hospital walls. (Courtesy of the collections of the North Jersey History Center, the Morristown and Morris Township Library.)

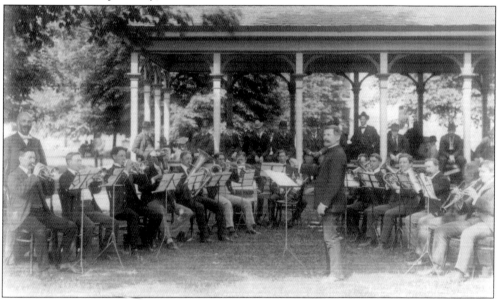

Music was omnipresent at the asylum. By 1880, a brass band consisting of staff members was assembled to entertain patients. By 1914, the brass band had become a full-fledged orchestra. Patients were also able to participate, but were only permitted to play string instruments. Brass pieces were considered too dangerous for a patient to yield, as they could make for dangerous makeshift weapons. (Courtesy of the Morris Plains Museum.)

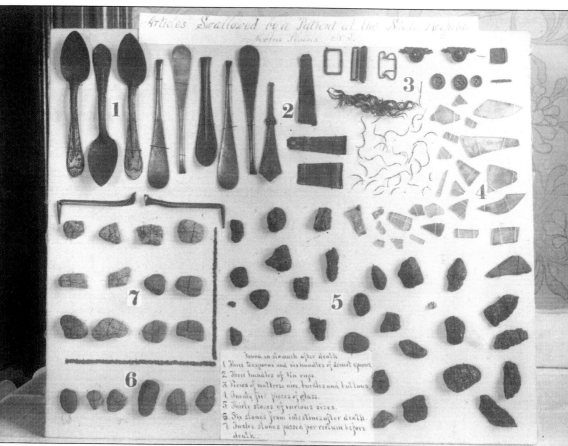

The rationale behind keeping brass instruments out of patient's hands was not without justification. Numerous patients suffered from chronic fits of inflicting harm on themselves or others. This photograph from 1899 shows items removed from a deceased patient's stomach. Commonly known as a "swallower," patients with this affliction were of particular concern, as nearly any object in their possession had the potential to cause harm. (Courtesy of the collections of the North Jersey History Center, the Morristown and Morris Township Library.)

Rhymes of a Raver

By

Richard David Comstock

PUBLISHED AT

THE PRINT SHOP *of* NEW JERSEY STATE HOSPITAL

Greystone Park, N. J.

In 1930, a book was published by Greystone's in-house printing press titled *Rhymes of a Raver.* It contained over a hundred pages of poetry composed by a patient named Richard David Comstock. The writings cover topics such as his daily life, the plight of the mentally ill, and fellow patients. It contains no shortage of praise for the asylum and staff. (Courtesy of the Morris Plains Museum.)

A Brother's Keeper

Oh, the bars, those bars, those rusty, taunting bars,
They choke me and they've broke me,
Those silent, mocking bars.

Here a soul begs to die, and another would dwell
Down here 'neath blue skies, and another craves hell,
Mumbling and gurgling, as dementia jars,
All trying to learn that weird song of the bars.

Ah, the bars, cold bars, those hideous, leering bars,
They taunt me and they flaunt me,
Those soul accusing bars.

They are kind to us here, or we'd falter and fall,
But there's merciful cheer 'twixt Greystone's grey walls.
And many glad hearts have wandered afar,
Strong, well, they depart from the song of the bars.

Ah, the bar, those bars, those life protecting bars,
Their misery's drawn with flash of dawn,
Those silent, guarding bars.

Taken on the rear campus of the hospital, this photograph captures a relatively simple moment in the daily life of a patient. A noteworthy element is the pyramid-shaped form on the lawn. These objects appeared in numerous locations on the hospital grounds and were actually ornately designed skylights that illuminated an underground subway system used for transporting patients and staff between different sections of the facility. (Courtesy of the Morris Plains Museum.)

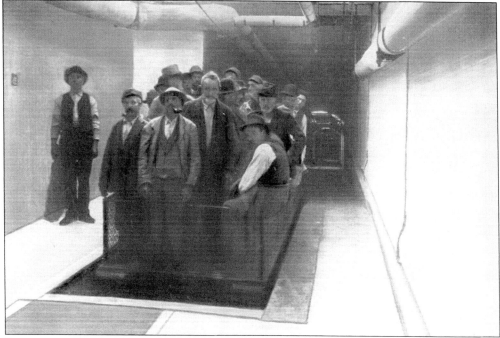

Patients are seen traveling via the underground subway in 1901. Though initially the system was limited, as the asylum grew over the years, so did the subway as it connected newer buildings on the grounds. (Courtesy of Pete Olin.)

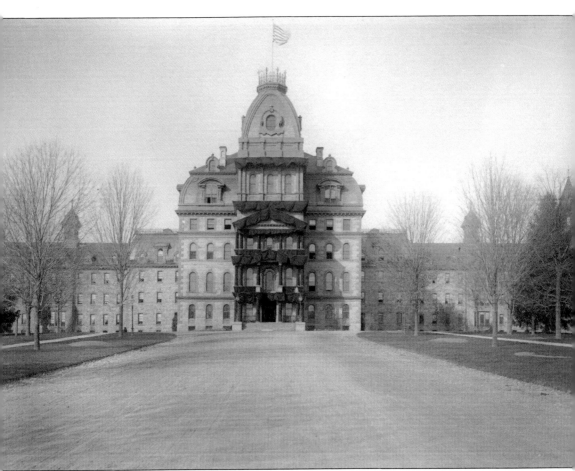

Greystone's Kirkbride building is seen dressed in mourning. On at least two occasions, following the deaths of high-ranking political figures, black bunting was placed on the face of the administrative portion of the asylum. This 1899 photograph is the first documented occurrence, showing Greystone draped for the passing of Vice Pres. Garret A. Hobart. (Courtesy of the collections of the North Jersey History Center, the Morristown and Morris Township Library.)

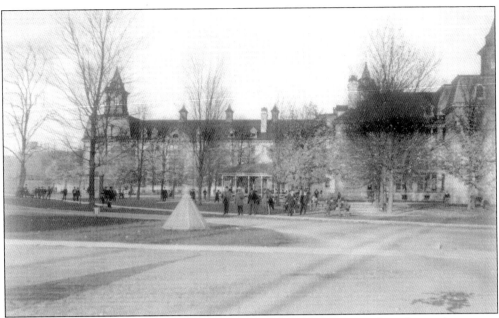

Taken on the rear campus of the hospital, this photograph captures a relatively simple moment in the daily life of a patient. A noteworthy element is the pyramid-shaped form on the lawn. These objects appeared in numerous locations on the hospital grounds and were actually ornately designed skylights that illuminated an underground subway system used for transporting patients and staff between different sections of the facility. (Courtesy of the Morris Plains Museum.)

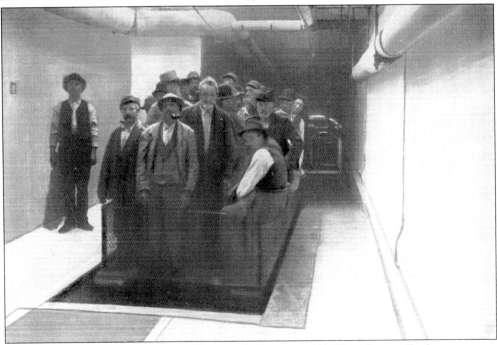

Patients are seen traveling via the underground subway in 1901. Though initially the system was limited, as the asylum grew over the years, so did the subway as it connected newer buildings on the grounds. (Courtesy of Pete Olin.)

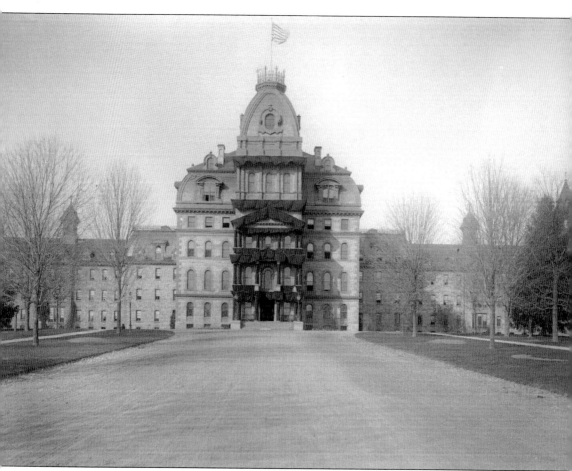

Greystone's Kirkbride building is seen dressed in mourning. On at least two occasions, following the deaths of high-ranking political figures, black bunting was placed on the face of the administrative portion of the asylum. This 1899 photograph is the first documented occurrence, showing Greystone draped for the passing of Vice Pres. Garret A. Hobart. (Courtesy of the collections of the North Jersey History Center, the Morristown and Morris Township Library.)

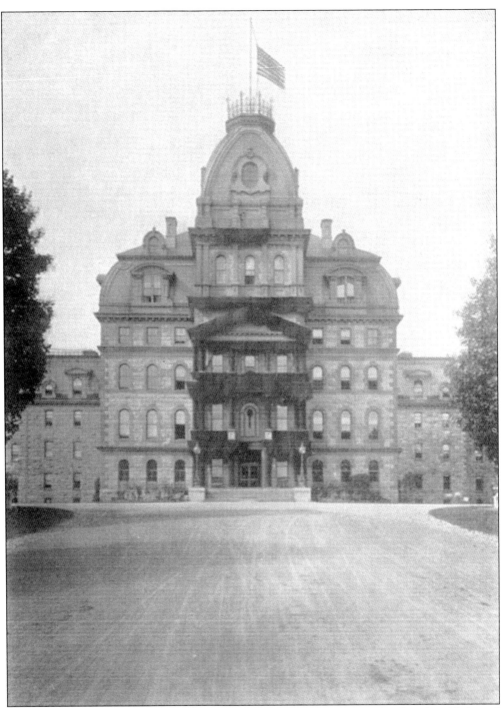

Just two years after the death of Vice President Hobart, Greystone once again found itself adorned in black, this time over the assassination of President McKinley in September 1901. Congress expressly prohibited federal buildings across the country from being draped for the mourning of President McKinley; rather, they were to fly their flags at half-mast. Greystone, being a state institution, honored the president with both. (Courtesy of Pete Olin.)

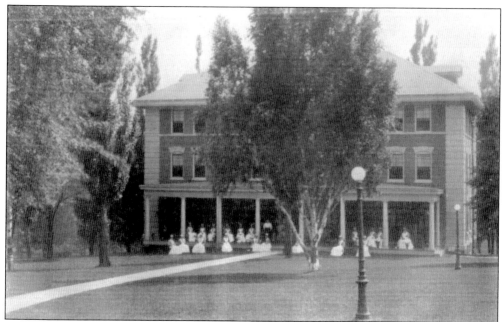

The ever-increasing number of patients at Greystone meant an ever-increasing staff to assist with their care. Nurses' cottages were constructed in front of the south and north wings in the early 1900s. The southern cottage was completed first, and the northern one a few years later, opening in 1912. These new buildings provided far more spacious living quarters and classrooms for nurses. Pictured is the southern cottage in 1909. (Courtesy of the Morris Plains Museum.)

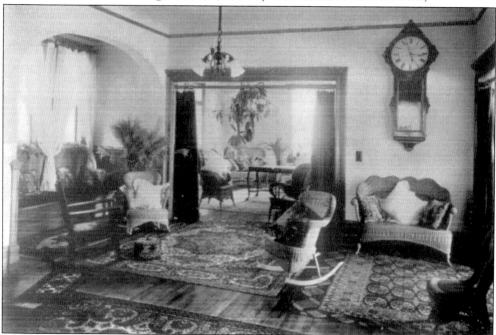

The beautifully appointed interiors of the nurses' cottages ensured they were unmistakably a part of Greystone. This 1905 photograph of the southern cottage's parlor illustrates just that, with fine rugs, wicker rockers, and as always, plentiful plant life. (Courtesy of the Morris Plains Museum.)

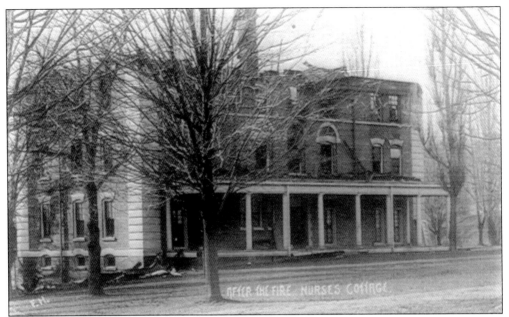

As well appointed as the new nurses' cottages were, one feature they were sorely lacking was fire escapes. In 1907, a massive fire gutted this cottage, badly burning three nurses. The cottage was quickly rebuilt, opening again in 1909. The frightening incident prompted the installation of fire escapes throughout the grounds. (Courtesy of the Morris Plains Museum.)

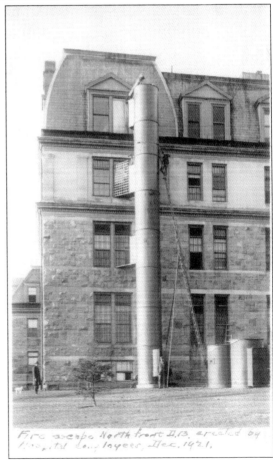

As noted in the handwriting at the bottom of this image, this fire escape was added to the front of the dormitory building by hospital employees in December 1921. Though crude by today's standards, up until these escapes were installed, there were no emergency exit routes at all on many of the buildings. (Courtesy of the Morris Plains Museum.)

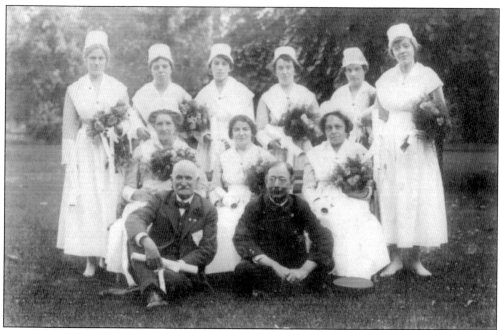

Pictured above is a group of nurses; below is an assembly of nurses and attendant staff in 1902. Many of the graduates from the nursing school did not stay at the asylum, and for those who did, there was no arguing that being a nurse at an institution such as Greystone was a demanding job. In fact, all staff positions in the hospital were demanding, especially considering the overcrowded conditions. As it was then and remains today, certain people thrive under those conditions—people who put others before themselves and who find their own reward in aiding those who need them. Greystone's staff was the lifeblood of the asylum. (Both, courtesy of the Morris Plains Museum.)

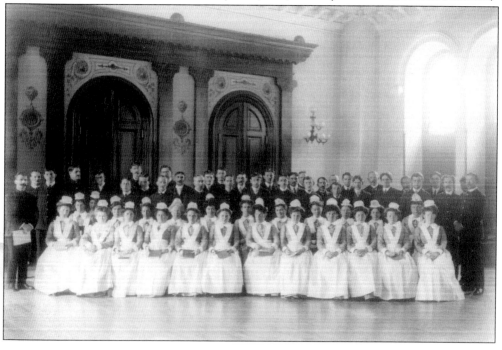

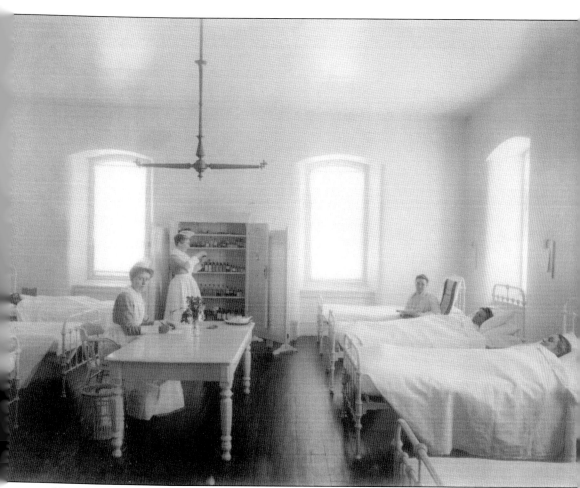

Here, nurses tend to patients in the female ward of the dormitory building. Brightly lit quarters were illuminated by numerous large windows, echoing the design principles present in the hospital's main Kirkbride building. (Courtesy of the Morris Plains Museum.)

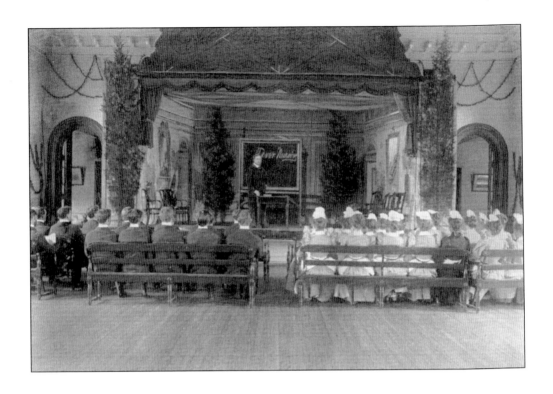

Above, an 1899 lecture for the nurse training school is taking place in the hospital's amusement hall. The raised stage-like area, blackboard, and curtained surround were all eventually removed when lectures relocated some years later into the expanded campus. Below is a photograph of one of the more modern lecture halls eventually built on the grounds. (Above, courtesy of Pete Olin; below, courtesy of the Morris Plains Museum.)

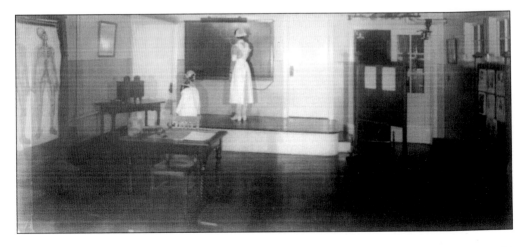

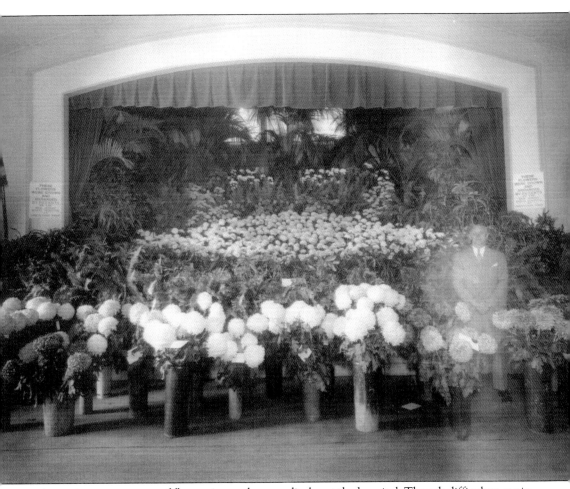

A massive arrangement of flowers is seen here on display at the hospital. Though difficult to see in this photograph, the placard on the wall reads, "These flowers were grown and arranged by patients at the New Jersey State Hospital at Greystone Park." (Courtesy of the Morris Plains Museum.)

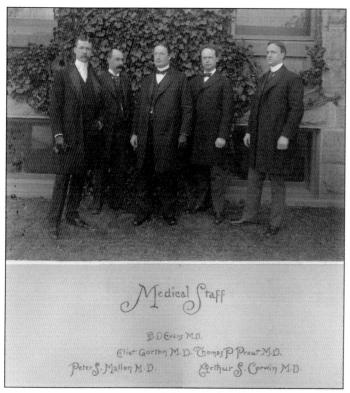

Medical Staff

B. D. Evans M.D.

Eliot Gorton M.D. Thomas P. Prout M.D.

Peter S. Mallon M.D. Arthur S. Corwin M.D.

Early on, it was customary for high-ranking members of the hospital staff to pose for photographs, usually in small groups on the staircase that led to the main entrance. These images were often utilized in reports to the state, as well as archived in the hospital's records. (Both, courtesy of the collections of the North Jersey History Center, the Morristown and Morris Township Library.)

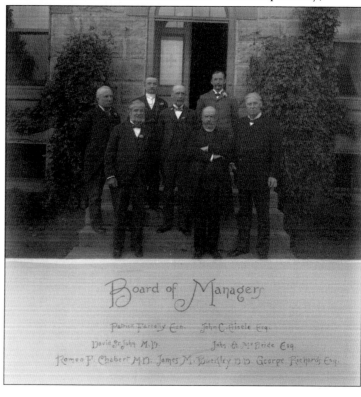

Board of Managers

Patrick Farrelly Esq. John C. Eisele Esq.

David St. John M.D. John G. McBride Esq.

Romeo F. Chobert M.D. James M. Buckley M.D. George Richards Esq.

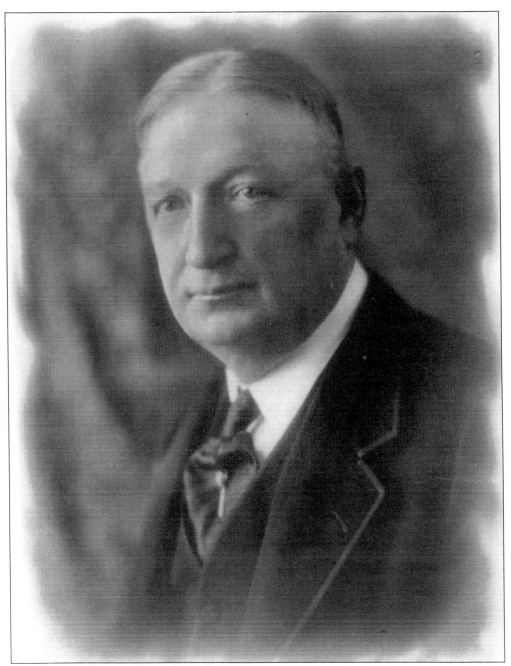

Dr. Britton D. Evans served as the medical director at Greystone from 1892 until his death at the hospital in 1920. During his tenure, he helped orchestrate many improvements and expansions to the facility, such as the dormitory building in 1901, and the hydrotherapy and electrotherapy treatments conducted there. He also oversaw the construction of the nurses' cottages, industrial building, and the dormitory annexes. He was responsible for helping get Greystone's wildly popular *Psychogram* magazine established through the patients' occupational therapy program. Beyond that, he kept Greystone well-orchestrated, even as the patient population grew to nearly 3,000. (Courtesy of the Morris Plains Museum.)

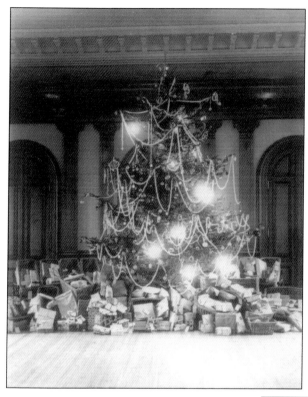

Christmas at Greystone was quite a spectacle. A massive tree stood in the asylum's amusement room, and all across the campus, holiday decor adorned the buildings inside and out. Under the tree could be found a tremendous mound of presents—one for every patient at the asylum to receive on Christmas morning—handed out by Santa himself. Dr. "Santa" Evans is seen below dressed the part during Christmas 1916. (Both, courtesy of the Morris Plains Museum.)

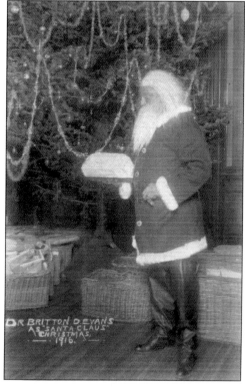

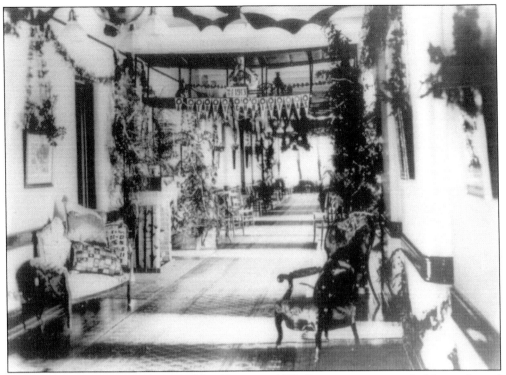

The women's ward is seen decorated for Christmas 1913. Streamers, signs, and ribbons adorned nearly every ward at Greystone during the holidays. Great efforts were put forth to ensure patients enjoyed the days leading up to the holiday as much as the day itself. (Courtesy of the Morris Plains Museum.)

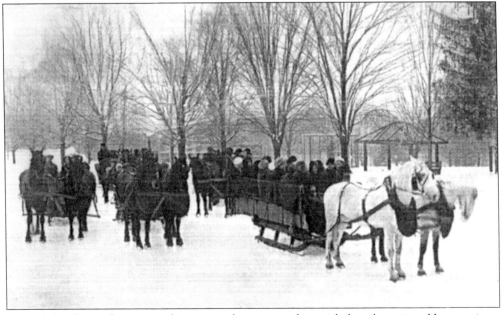

Beyond the decor, there were plays, musical events, and special chapel services. Here, patients enjoy sleigh rides in the winter of 1916. (Courtesy of Pete Olin.)

This poem from *Rhymes of a Raver* narrates, in profound detail, the experience of living within Greystone during the Christmas season. The fact that it was written by a patient adds incredible weight to the words and thoughts. (Courtesy of the Morris Plains Museum.)

Greystone's Holy Night

'Twas in a great hospital
One gladsome Christmas eve,
We gathered in the ballroom
Around the sparkling tree.

We saw a gloried pageant,
Heard carols gaily sang.
How the chorus reverberated
As we joined the glad refrain.

There was joy on every countenance,
Every heart was free and light,
Glory, goodwill, peace and laughter
Reigned at Greystone's Holy Night.

"Why should I call that night holy?"
If you could have seen the looks
That leaped from happy faces
As they clutched their carol books,

You would say, "The spirit of Jesus
Must be floating everywhere,"
As they sat and eyed those presents,
In their eyes a thankful prayer.

Some had only come to Greystone,
Many lingered there for years,
Some would soon be well, and leaving
Others doomed to dwell in fear.

But to-night they all were happy,
Not a sign of sorrow's blight;
And they laughed, and talked, and warbled
There on Greystone's Holy Night.

With the sound of sleigh bells ringing
Santa strode on down the aisle,
With his funny paunch like jelly,
And a merry, carefree smile.

As he stood before his subjects
And looked o'er the radiant throng,
Stealing o'er us crept a feeling
Like a bound heart's stifled song.

Something gripped him, held him silent,
And his smile was twisted now,
As he gazed out o'er the masses,
Grave, the furrows at his brow.

And a look of sincere pity
Floated outward with his sight,
As he spoke to those he treasured
There on Greystone's Holy Night.

Then he spoke, and words of wisdom
Floated out about the room,
And the tone of friendship blended
With the echoed carols' tune.

An outdoor auditorium and amusement hall stood on the property out front to the east of the southern ward wing of Greystone's Kirkbride building. It was used regularly, primarily for dances and musical events. (Courtesy of the Morris Plains Museum)

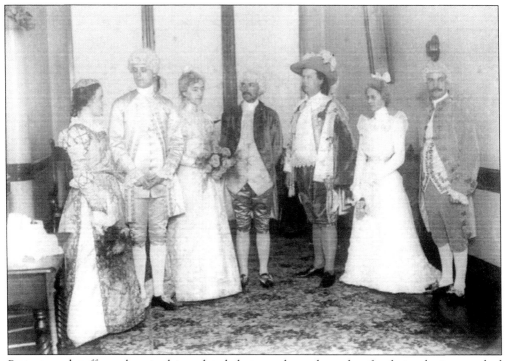

Patients and staff members in this undated photograph are dressed up for their roles in a masked ball. (Courtesy of Pete Olin.)

61

Mar. 11, 1912

Mr. William Ayres,

 Farm.

Dear Sir:-

 For a considerable length of time, I have noticed that the employees of the several departments are not being governed by the time set for beginning and stopping work.

 It is understood and is indicated by the blowing of the whistle that 7 o'clock is the time set for commencing work each day, 12 o'clock dinner hour, work to be resumed at 1 o'clock. Despite this rule, there are a number of persons who do not pretend to reach the hospital on time, much less being prepared to begin their duties.

 The conditions are the same as regards the time of quitting work, which, as the whistle indicates, is five o'clock P. M. Regardless of this, there are many who discontinue work as early as half an hour before the regular time, to make preparations for leaving when the whistle blows, and in addition to this, leave the institution before the whistle sounds. The number of hours have been specified as constituting a day's work, and each man is paid accordingly, and unless employees render the service that is due, they are not entitled to receive the wages which are based upon the working hours as specified.

 From this day I will hold you, as foreman of your department, personally responsible for the work done by the men in your department, also the time that they report for duty and the time leaving. In addition, I shall hold each man personally responsible, and I wish you to notify one and all that, unless the rules established are strictly adhered to, both the man in charge and the person violating the rules will be discharged.

 Yours truly,

 Warden.

Here is a rather stern letter, dated March 11, 1912, regarding some less-than-motivated staff members. (Courtesy of the Morris Plains Museum.)

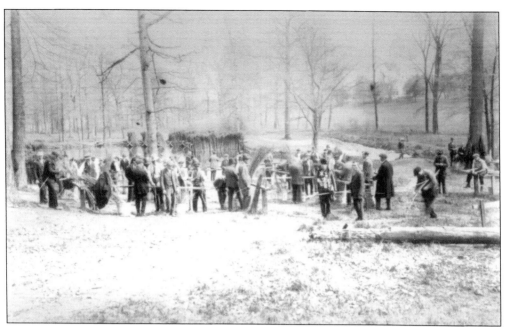

Much of Greystone's furniture was made by patients. From its beginnings in the earth, to its final form as a fixture in the hospital, every step was completed by a patient through various work programs. Here, the harvesting of willow for use in furniture-making sessions is seen. At times, furniture became surplus, and during those occasions, it was not uncommon for items to be shipped out for sale on the railway that ran through the campus. (Both, courtesy of the Morris Plains Museum.)

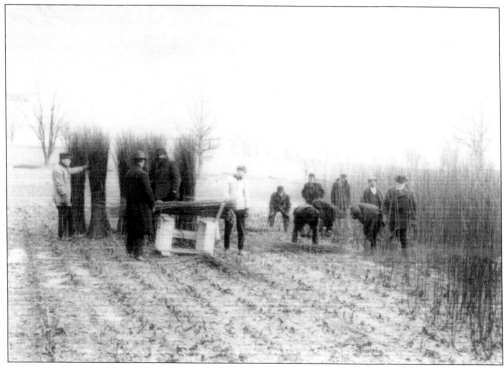

Occupational Therapy Exhibit And Field Day State Hospital Saturday

The great outdoor event of the year at the State Hospital at Greystone Park, the Annual Field Day, Occupational Therapy and Physical Education exhibitions, with other attractive features, will be held this Saturday.

The excerpt above is from the *Morris Plains Chronicle* of September 20, 1929, and heralds the annual Greystone field day. Birthed as an outdoor activities day for patients, the event evolved throughout the years to include a vast assortment of activities and events. There were competitions between patients as well as patients and staff, live performances, and constructed displays showcasing examples from various work programs, such as furniture making, horticulture, and the print shop. Unfortunately, due to overcrowding and under-staffing, the final field day took place in 1932. (Both, courtesy of the Morris Plains Museum.)

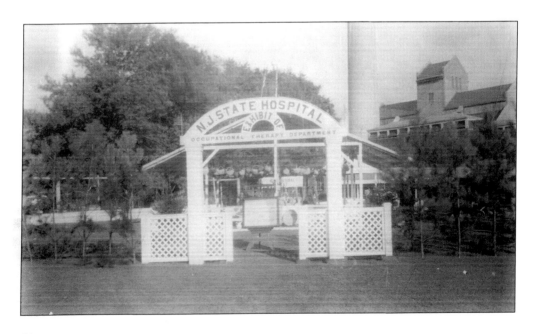

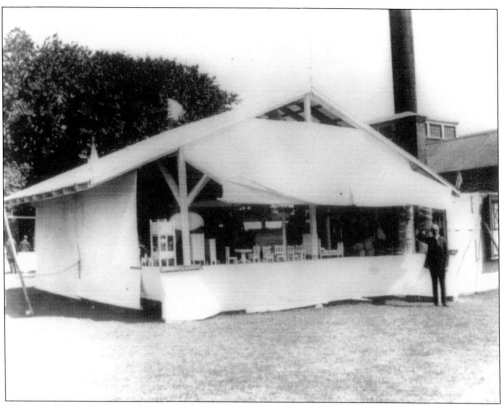

These field day displays showcase the works of patients in wood and wicker constructions. At times, goods were sold, but the main purpose of these exhibits was to allow the public to see firsthand the craftsmanship and imagination that the patients of Greystone were capable of. (Both, courtesy of the Morris Plains Museum.)

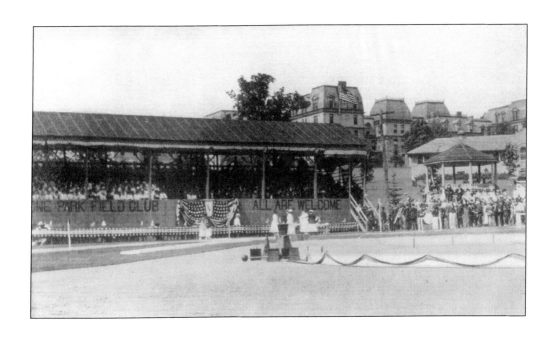

Field day activities primarily took place on the athletic fields between the Kirkbride and dormitory buildings on the southern portion of the property. In both these images, the dormitory can be seen upon its knoll in the background. (Both, courtesy of the Morris Plains Museum)

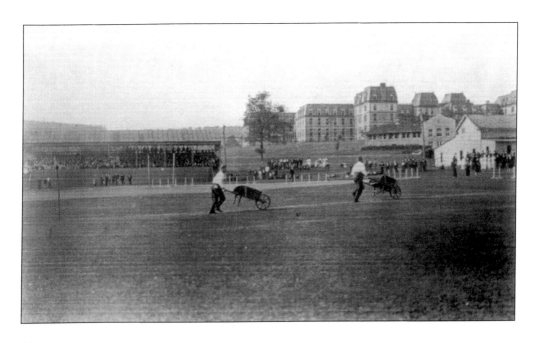

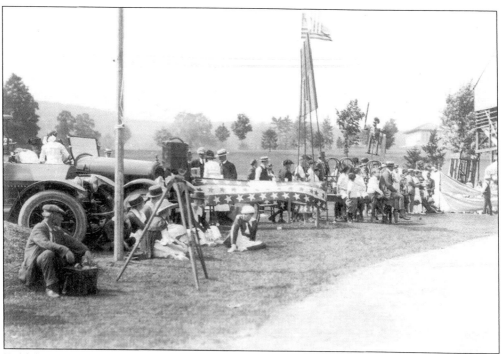

Field day attendees and onlookers gather around the circus ring constructed on the activities field to watch the antics of the Four Ding Circus. (Courtesy of Pete Olin.)

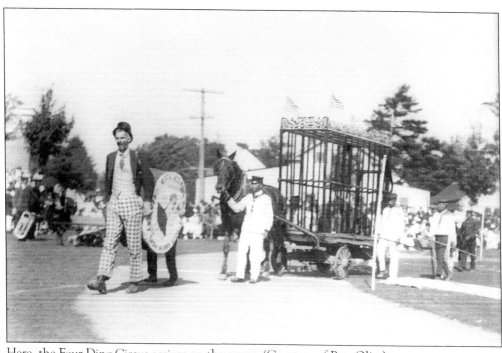

Here, the Four Ding Circus arrives on the scene. (Courtesy of Pete Olin.)

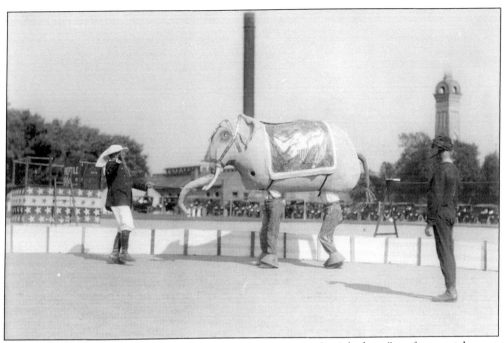

An "elephant" performs tricks for the ringleader, and a monkey flips about inside (and outside) a cage. For obvious reasons, an actual elephant would have never been considered for field day. Instead, whimsical costumes were constructed to be worn by performance artists. (Both, courtesy of Pete Olin.)

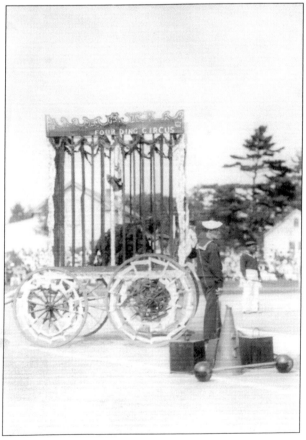

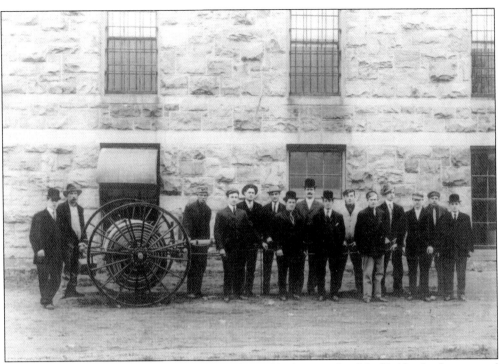

The state hospital fire department was formed in 1890. A principle of the Kirkbride plan, around which Greystone was built, was to minimize wood and utilize as much stone and brick in the construction as possible. In doing this, it was thought that the risk of large-scale fires would be greatly reduced. This was proven untrue by 1930, years after these photographs of the 1902 fire crew and 1915 fire drill were taken. (Both, courtesy of the Morris Plains Museum.)

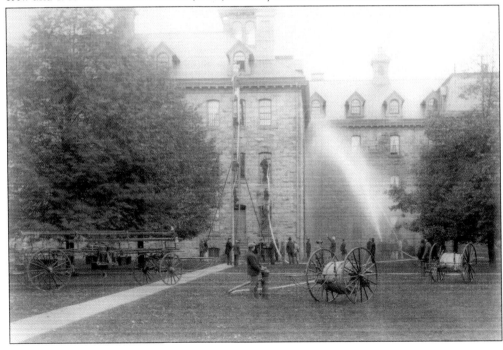

In 1912, a tuberculosis building was constructed in an effort to combat what was becoming a very serious problem in the overcrowded hospital. In 1906 alone, over 20 patient lives were claimed by tuberculosis. (Both, courtesy of the Morris Plains Museum)

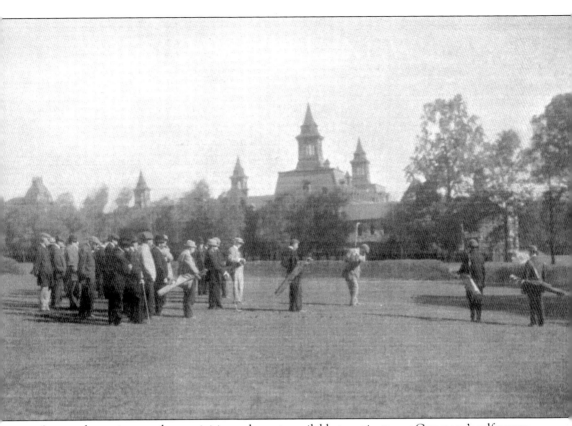

Among the copious outdoor activities and events available to patients was Greystone's golf course, which seems to have nearly been lost to the annals of history. Rounds of golf could be played and watched by patients. This 1916 photograph shows just that, with the Kirkbride building's spires visible in the background. (Courtesy of the Morris Plains Museum)

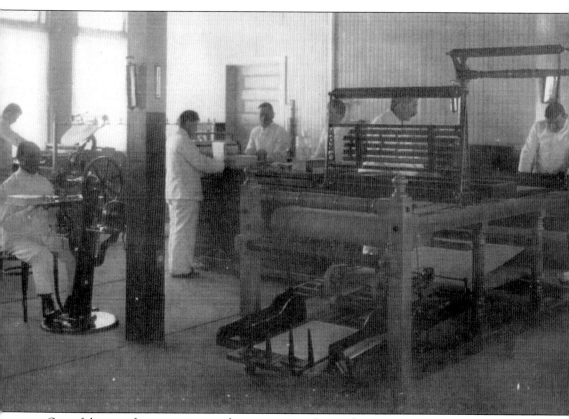

One of the most famous patient work programs was the *Psychogram*, which got its start out of the patient print shop in 1916. The *Psychogram* was a monthly newsletter written, edited, designed, printed, and bound by patients for patients. The content ranged from creative fiction and poetry to news. (Courtesy of the Morris Plains Museum.)

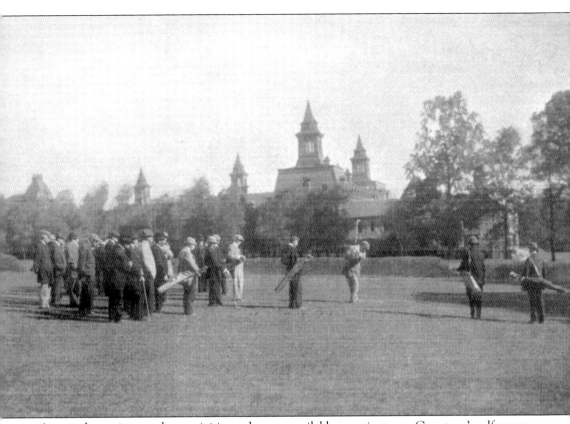

Among the copious outdoor activities and events available to patients was Greystone's golf course, which seems to have nearly been lost to the annals of history. Rounds of golf could be played and watched by patients. This 1916 photograph shows just that, with the Kirkbride building's spires visible in the background. (Courtesy of the Morris Plains Museum)

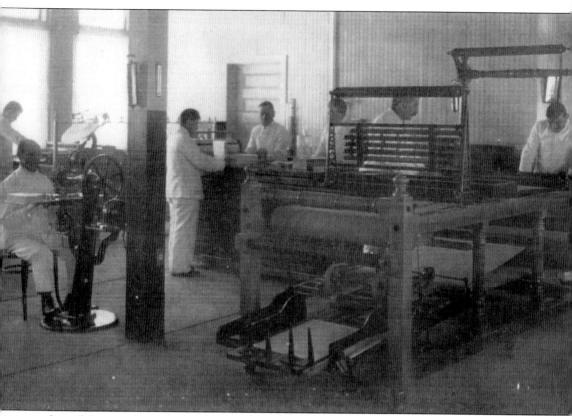

One of the most famous patient work programs was the *Psychogram*, which got its start out of the patient print shop in 1916. The *Psychogram* was a monthly newsletter written, edited, designed, printed, and bound by patients for patients. The content ranged from creative fiction and poetry to news. (Courtesy of the Morris Plains Museum.)

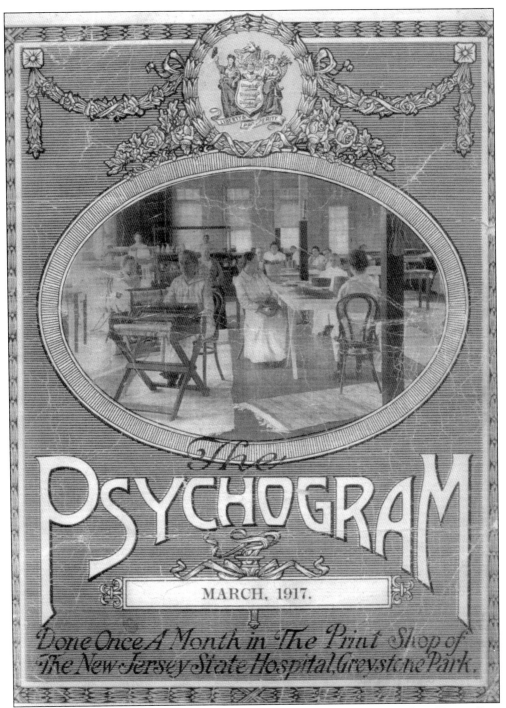

The
PSYCHOGRAM

MARCH, 1917.

Done Once A Month in The Print Shop of
The New Jersey State Hospital, Greystone Park.

A 1930 issue of the *Morris Plains Chronicle* celebrated the *Psychogram*'s birthday: "Twenty-Four years ago this week an idea was born at Greystone Park which, although unique then, was to become accepted throughout the world as one of the great advances in occupational therapy." (Courtesy of the Morris Plains Museum.)

The Psychogram

ORIGINAL POEMS BY PATIENTS

The *Psychogram* had much success from day one and has proven to be an invaluable window into the minds of those who once called Greystone home. (Courtesy of the Morris Plains Museum.)

A Delectation

There stands on a hill, these massive grey walls,
With roofs and towers, for miles can be seen,
Where in this bedlam, live souls in its halls,
And bars of iron on windows, each have screen;

This park has trees, flowers, a campus green,
With hills, forests, on all sides; unique
Are its grounds, buildings, as they stand between,
The hills of scenery, are seen picturesque.

Up in the early morn, the golden sun,
Rose bright in skies of blues, o'er field and wood,
Through which its hives where men walk and run;
They labor on for justice, love and good,

For human rights of home, and State and Nation;
Let each soul have its need for God and men,
With long life on earth, in true salvation,
His grace and power, Poet's love from his pen.

—R.W.E.

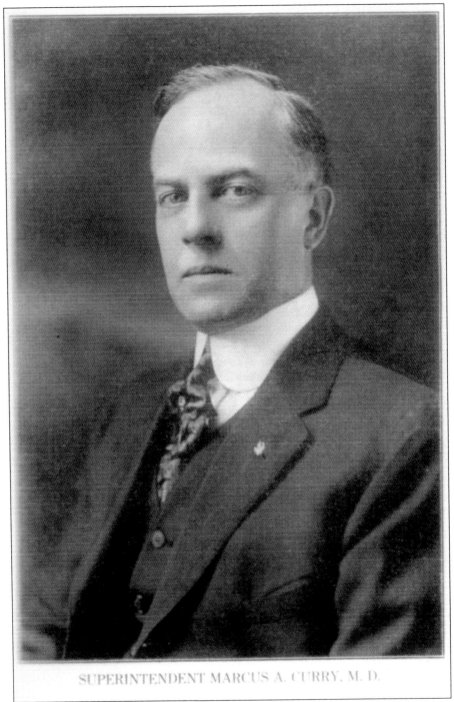

SUPERINTENDENT MARCUS A. CURRY, M. D.

In 1920, Dr. Marcus A. Curry replaced medical superintendent Britton Duroc Evans after he passed away in office. On his first day on the job, Dr. Curry had all locks removed from patients' rooms. He went on to become perhaps the most revered superintendent in Greystone's history. Under his stewardship, Greystone, even though overcrowded, fostered an air of human warmth and compassion, which was integral to the Kirkbride plan. (Courtesy of the Morris Plains Museum.)

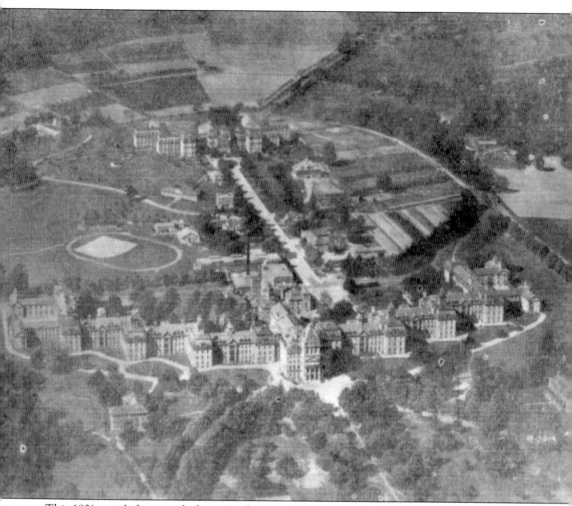

This 1921 aerial photograph shows just how much Greystone had expanded since its opening 45 years prior. What was once a single Kirkbride building on a hill had come to be a bustling hub of activity. It was just miles from the surrounding towns, but due to its isolated nature, it remained a world away. The expression "a city unto itself" was widely used when talking about the asylum, and there were no better words to describe it. (Courtesy of the Morris Plains Museum.)

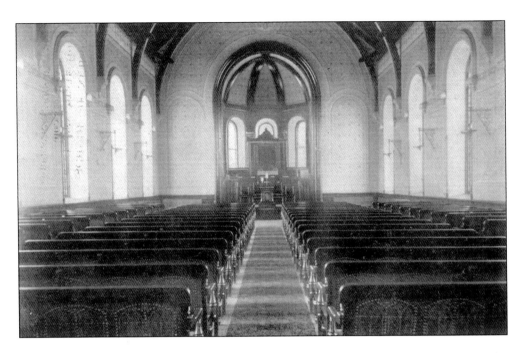

As turbulent as times were at Greystone throughout the years, there was always sanctuary to be found in the Greystone chapel. Greystone's famous chapel was perhaps the most often referenced and fondly remembered room in the entire facility. Peggy Mesinger, the former director of pastoral services, had this to say about the old hall of worship: "That was such a magic space. Patients would walk in, and when they went through the threshold something happened to them . . . they were the person they wanted to be." (Both, courtesy of the Morris Plains Museum.)

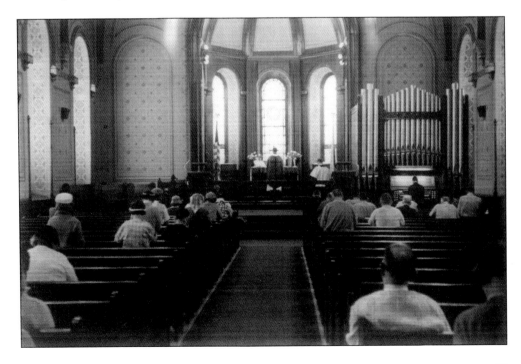

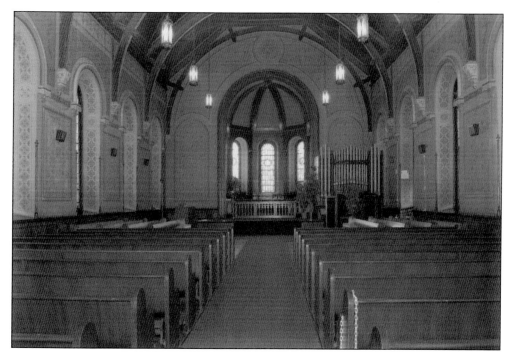

Unlike the greater asylum and grounds surrounding it, the chapel remained more-or-less unchanged from opening day until the last brick fell during its demolition. Aside from new pews and a relocated pipe organ, one could enter this massive room at any point throughout Greystone's years of service and be hard-pressed to notice a difference between the centuries. These modern photographs were taken in 2008, after Greystone had been fully shuttered. (Photographs by Christina Tullo.)

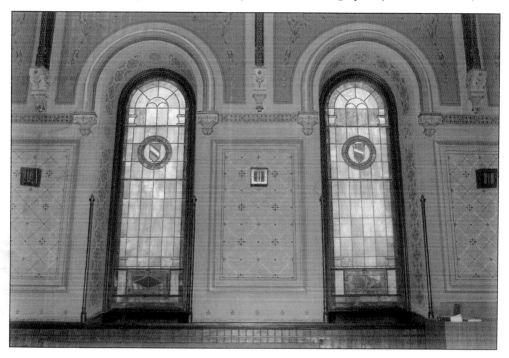

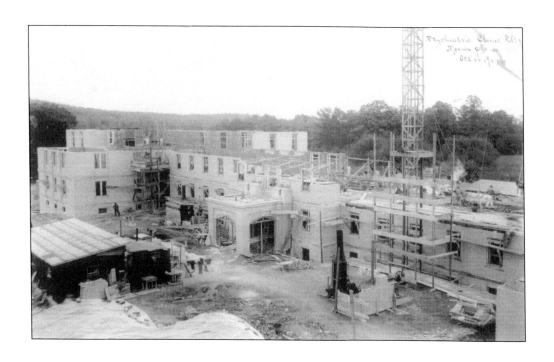

Spurred by overpopulation, 1920–1921 saw the construction of a large building on the Greystone campus known as the psychiatric clinic building, or just "clinic building," as it would later come to be called. (Both, courtesy of the Morris Plains Museum.)

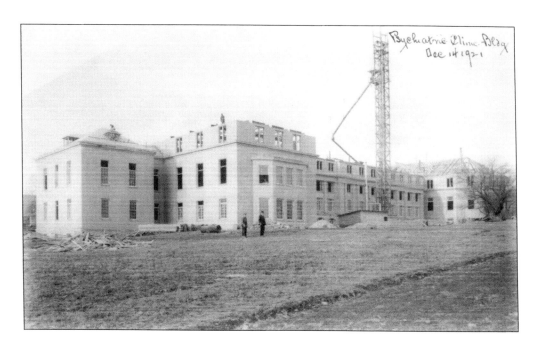

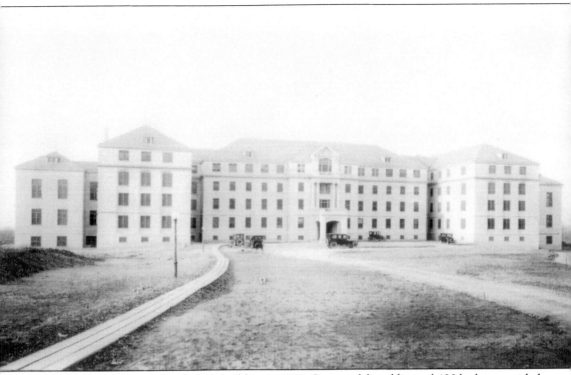

Here is the newly completed clinic building in 1922. On top of the additional 400 beds it provided for the still-overburdened asylum, this building served as the new medical facility for the grounds. Years later, work done here would prove of national import, as the Columbia-Greystone Project conducted a years-long study that refuted the benefits of lobotomies, which ended the practice in institutions across the country, saving untold lives. (Courtesy of the Morris Plains Museum.)

In 1927, the Marcus A. Curry Building opened. It was most commonly referred to simply as the "Curry Building," and housed offices for admissions as well as additional housing for the overwhelmed asylum. The photograph below shows the initial paving of the building's lot in 1928. A steam-powered pavement roller is on the right. (Both, courtesy of the Morris Plains Museum.)

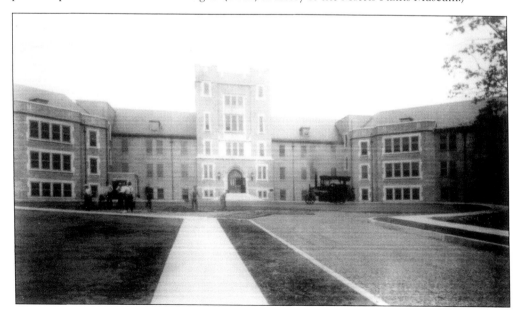

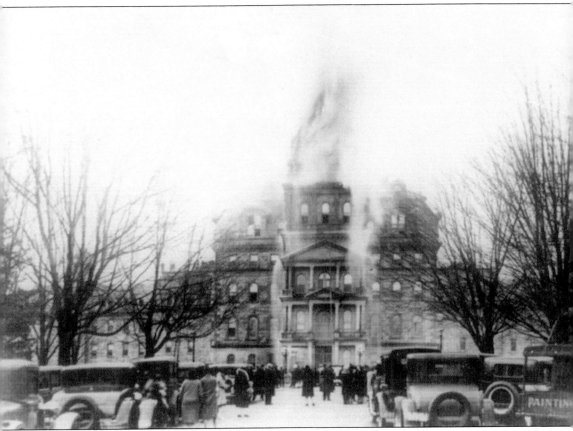

On November 26, 1930, the largest disaster in Greystone's history occurred when electrical wiring in the uppermost floor of the hospital ignited a fire that burned within the walls. The flames quickly spread, strengthened by the building's airy design and the wooden construction of the roof's massive dome. Though the asylum had already experienced two larger fires in the previous years, which severely compounded already stressed living conditions in the overcrowded hospital, this one was much greater both in magnitude and in damage. This dramatic event forever changed life within the asylum, as well as the very shape of the building, since many of the original fixtures were devoured by the flames. (Courtesy of Pete Olin.)

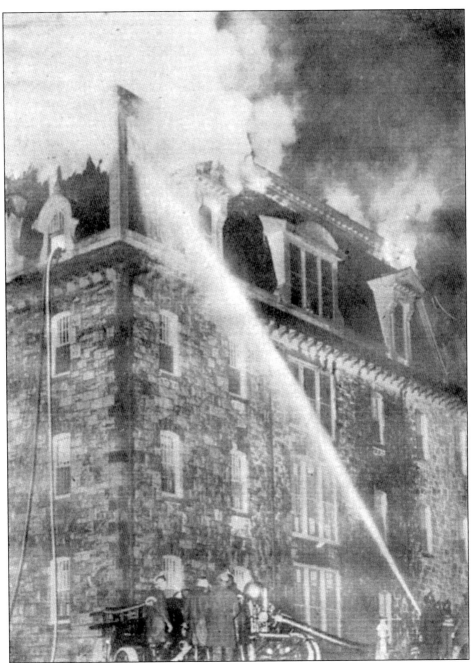

In the 1931 annual report, Dr. Curry lamented the events of November 26: "In the realm of disasters and other conditions beyond immediate control, this has been the most depressing year experienced during the period of my connection with the hospital and probably in the entire history of the institution. Last year in my report to you I was obliged to refer rather frequently to the over-crowding and general stress which followed the great fire of May, 1929, and which had been further increased by the unparalleled admission rate. At that time I stated that we must be prepared to make even more difficult adjustments during the coming year, but of the actual extent of the trials in store for us I had no intimation." (Courtesy of Pete Olin.)

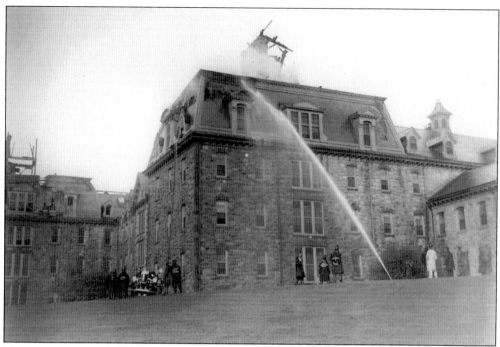

Dr. Curry continued: "The fire spread under the floor to the timber construction between the exterior slate-covered roof and the interior plastered wall and followed this wood frame work. Because of its position concealed behind the wall from the inside and under the roof from the exterior it could not be easily located by the fire fighters and when it appeared to have brought entirely under control it would suddenly burst out at some distant point. The dry and seasoned timber and the great distance around the Center structure gave abundant material for the flames. The tower in particular, with its wood construction and with large windows to increase the draft, burned so strongly that water seemed to have no effect upon it." (Above, courtesy of Chandra Lampreich; below, courtesy of Pete Olin.)

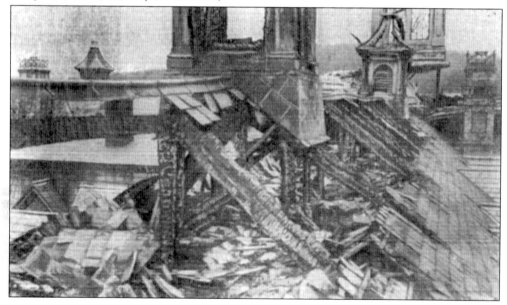

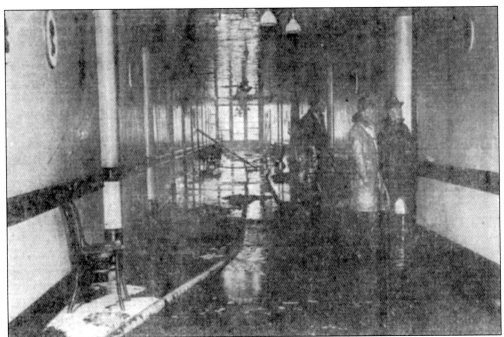

Firefighters stand in a washed-out ward inspecting the extensive damage. While much of the hospital was consumed by flames, the damage caused by water was far greater. (Courtesy of Pete Olin.)

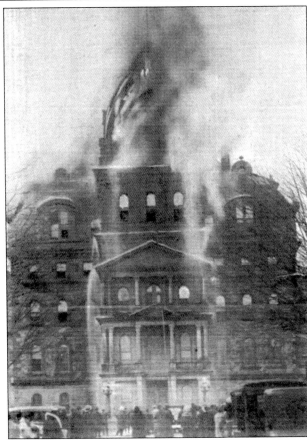

This is the last photograph ever taken showing Greystone with the original roof intact. (Courtesy of Pete Olin.)

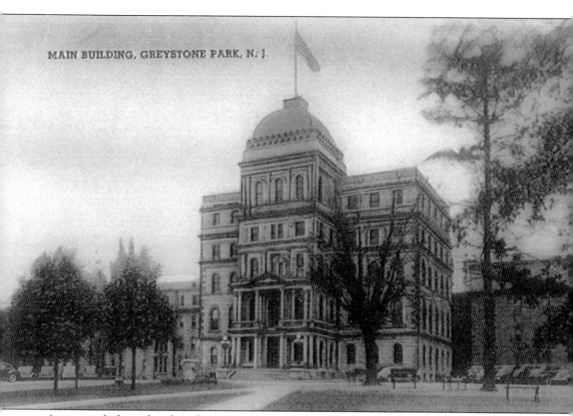

MAIN BUILDING, GREYSTONE PARK, N. J.

A new roof of wood-and-steel construction was immediately erected to cap the administrative portion of the Kirkbride building. Though it bore a resemblance to the original dome, this new roof was far less ornate in design. The upper-most floor of the entire facility was also altered to mirror that of the flat stonework walls on the floors below, doing away with the dormer windows and replacing the whole of the building with a plain flat roof. (Courtesy of the Morris Plains Museum.)

This 1936 photograph shows the completed fourth floor of the hospital, having undergone heavy rehabilitation and alteration after the fires of 1929 and 1930. Gone were the hospital's trademark spires and slant-faced roofing; all were replaced by a faux-stonework facade and plainly utilitarian-designed roof. (Courtesy of Pete Olin.)

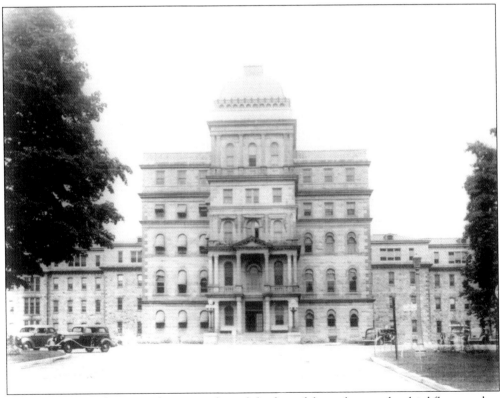

The large stonework portico that once adorned the face of the asylum on the third floor was lost in the fire, never to be replaced. Though the remodeled hospital was far less intricate in design, it still emanated a stately presence, especially when approached up the main drive toward its front doors. (Courtesy of the Morris Plains Museum.)

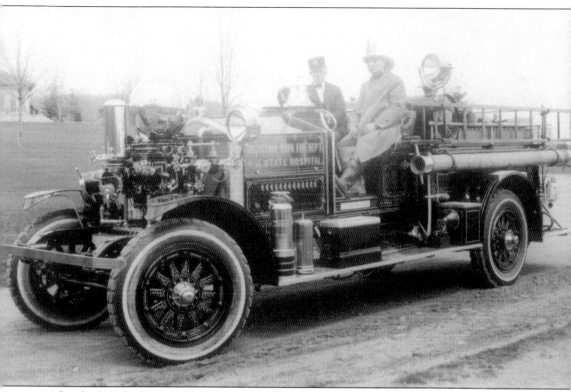

After the fire of 1930, a terrible situation that was compounded by Greystone's own fire department being woefully unprepared for a fire of that magnitude, the asylum fire department was granted an upgrade. This 1954 photograph shows a Greystone Park fire engine, driven by Robert Booth Sr. and accompanied by William Mathews, who was the first paid chief of the Greystone Fire Department. Mathews, having been chief since 1922, had experienced all three of Greystone's notable fires. (Courtesy of the Morris Plains Museum.)

Three

DOWNWARD SPIRAL

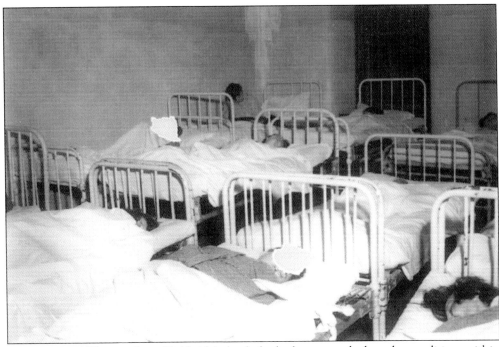

By the time of Thomas Story Kirkbride's death, he had come to deplore the conditions within the asylums that he helped to create. What were once bright, airy, opulent resort-like facilities had come to be the very things that he fought so hard to undo. Once again, the mentally and physically handicapped were being warehoused, this time within his very creations. Gone were Greystone's brightly sunlit rooms, replaced now by an inky gloom. The open-air design of the hospitals' halls and wards was being put to use, not for patient rehabilitation, but to fill with ever-increasing beds for the patients. By 1954, the total number of patients peaked at 7,674. (Courtesy of the Morris Plains Museum.)

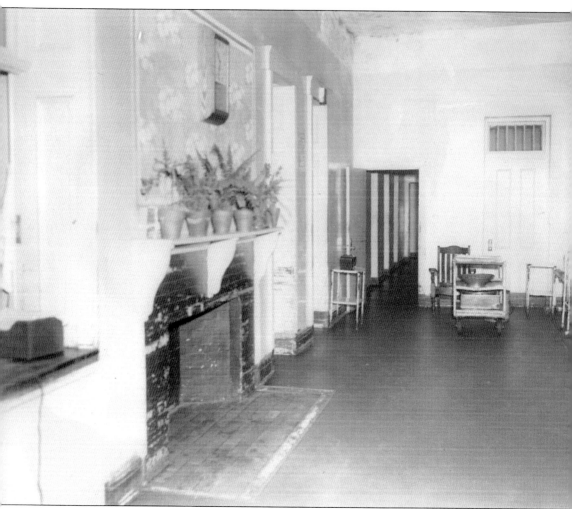

This 1953 photograph from the dormitory building shows that the aging structure was getting to be more than a bit rough around the edges. Peeling paint and water damage slowly replaced ornate woodwork, intricate murals, and elegant furniture. The once bright asylum had come to be a depressing sight. Echoes of the hospital's past grandeur were still present, but now, they served simply as sad reminders of an era that was never to return. (Courtesy of Pete Olin.)

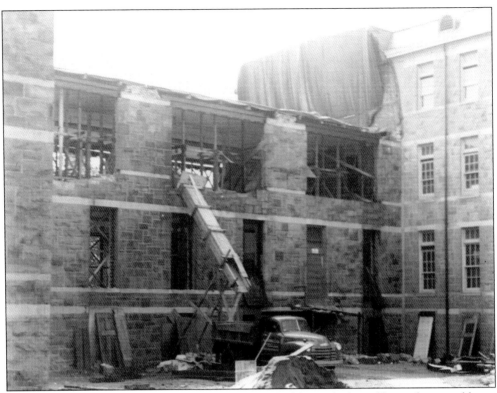

In the 1950s, additions were made to the dormitory building, which itself served as an addition some 50 years prior. Conditions were in a downward spiral at this point, a culmination of severe over-population, under-funding, and a staff that, like the asylum, was being taxed well beyond their capabilities. (Both, courtesy of Pete Olin.)

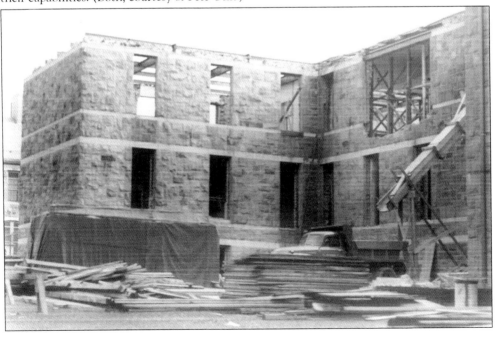

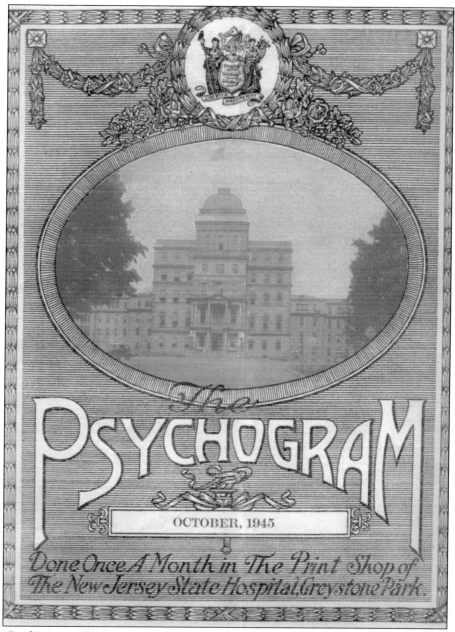

This *Psychogram* and accompanying patient-written excerpt from 1945 show that there was still beauty to be found at Greystone, even among the increasingly difficult living conditions. (Courtesy of the Morris Plains Museum.)

> There is nothing so breath-taking, so
> impressive, so powerful in its sublimeness
> of authority as the canopy of glory which
> usually is so evident in the heavens at
> midnight over Greystone Park.

—E.J.S.

Plaques such as this marked the borders of Greystone Park property. Once, they were seen as welcoming signs; however, they became warnings. What was once considered a palace of renowned beauty was quickly gaining a reputation as a dangerous place to be around, and Greystone Park was avoided as much as possible. It was not uncommon for parents in the area to threaten their children with being sent to live at Greystone if they misbehaved. (Courtesy of the Morris Plains Museum.)

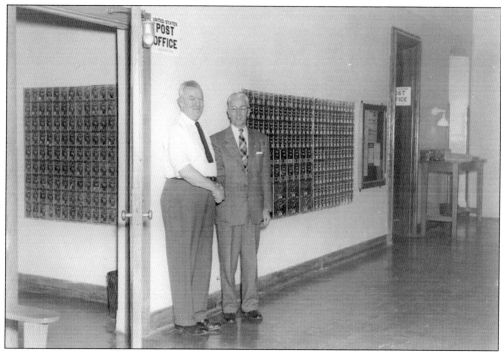

Greystone was a very large facility, and even early on, the need for a post office was obvious. Here, Supt. Dr. Archie Crandall (right) stands with the Greystone postmaster. The asylum had its very own self-contained post office, with a separate mailing address from the rest of the area. Letters addressed to and from here were marked as "Greystone Park, NJ." (Courtesy of Pete Olin.)

Superintendent Crandall inspected incoming letters and parcels for dangerous weapons. Of particular concern were hacksaw blades, which were at times used for escapes. Greystone came to suffer from more and more escapes as time went on, which understandably did not sit well with the neighboring communities. (Courtesy of Pete Olin.)

The hospital had radio since the 1920s, and television was introduced to the asylum in the early 1950s. What had first been brought in to entertain and stimulate the patients became a crutch, a distraction to occupy patients and alleviate some stress from the overburdened staff. (Courtesy of Pete Olin.)

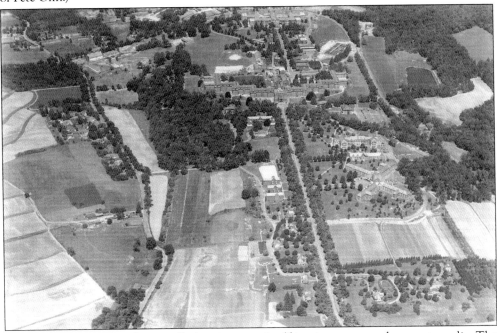

What was from very early on called a city unto itself in time came to be a metropolis. The original Kirkbride building can be seen toward the top of this 1970s aerial photograph, with the dormitory building just behind it. All down the long drive that leads to Greystone's front doors can be seen the hospital's sprawl, which continued to grow over the years. Outbuildings of various kinds, as well as dwellings for staff members and their families, filled what was once open fields and farmland. (Courtesy of Pete Olin.)

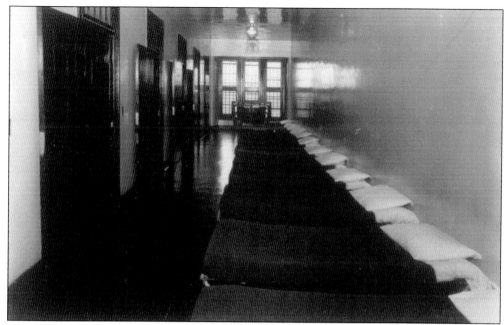

This undated photograph illustrates just how bad the population problem became at Greystone. These tightly-packed beds line a ward hall directly across from the spacious rooms that were designed to house a single patient. Greystone had extremely wide corridors for a Kirkbride building, an intentional design taken from lessons learned at previous asylums in which the hallways proved to be too tight. They were to allow for freedom of movement for the staff and patients living here and were never meant to house sleeping patients. (Courtesy of the Morris Plains Museum.)

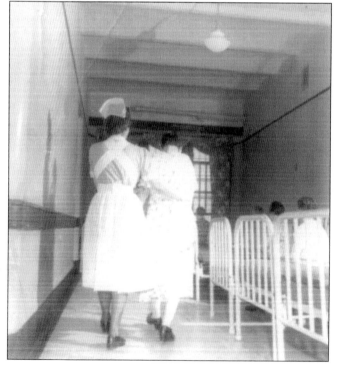

A nurse helps a patient down an overcrowded corridor in the women's ward. Though terribly overwhelmed, many of the staff members at the asylum were not to blame for the unsavory conditions. As in most instances where people are under acute stress for long periods, some of the staff did indeed fail in their duties, resulting in various forms of abuse to the patients. Though undeniably awful, this led to the unfortunate situation wherein the general public viewed all Greystone staff as negligent. This was not the case, and for those who struggled day in and day out to care for the patients, it made their jobs far more difficult. (Courtesy of the Morris Plains Museum.)

Picket Lines At Greystone

In the 1970s, Greystone had begun accepting inmates who were incarcerated on criminal charges. Murderers and other violent offenders were now being housed in state asylums due to insanity pleas in court hearings. This only compounded issues with patient population and control and further stressed an overworked and understaffed hospital to the breaking point. The asylum experienced 137 escapes in 1978 alone, some of which were murderers. This 1980s photograph from the *Daily Record* shows employees picketing at Greystone's front steps; they were protesting unsafe and overwhelming working conditions. (Both, courtesy of the Morris Plains Museum.)

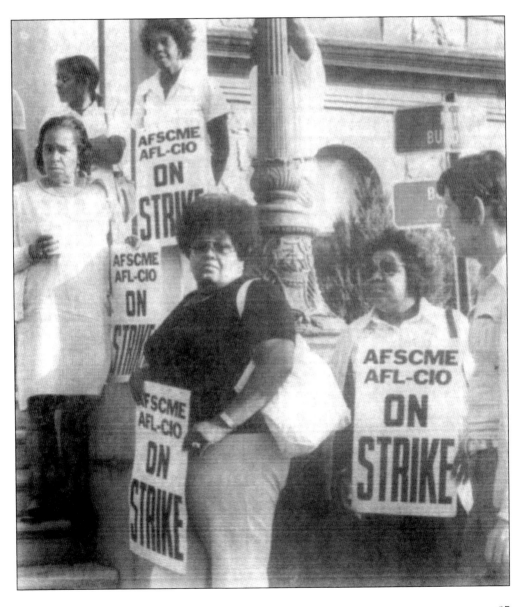

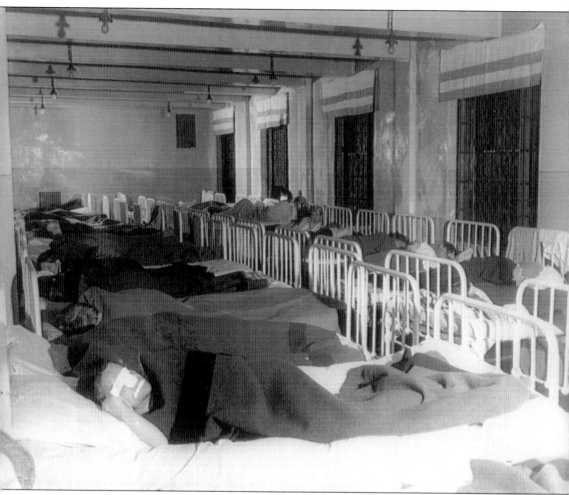

By the 1970s, a wave of deinstitutionalization was sweeping the nation, brought on by widespread accounts of patient abuse and neglect and the advent of psychotropic drugs that made patients easier to manage, which meant they could be housed in smaller group settings outside of massive asylums. In a reversal of most of Greystone's history up until then, the asylum experienced a massive exodus. By the mid-1980s, Greystone's Curry and clinic buildings were shuttered and abandoned. (Courtesy of the Morris Plains Museum.)

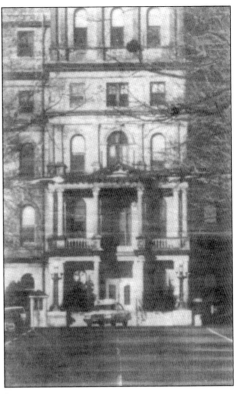

The word "asylum" means "a place of refuge." Overpopulation and understaffing had come to dissolve any semblance of that meaning within the walls of Greystone. The lack of control at the hospital occasionally made headlines when it manifested in the form of patient suicides. Sadly, according to staff at the time, these kinds of instances were almost unavoidable given the conditions in which the hospital was forced to operate. In the image at right, a police car is parked outside the hospital entrance. (Both, photographs by the *Daily Record*, courtesy of the Morris Plains Museum.)

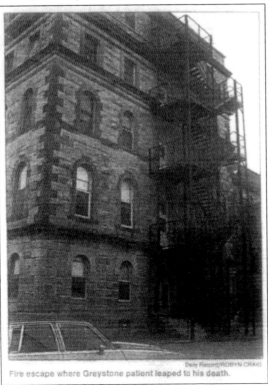

Daily Record/ROBYN CRAIG
Fire escape where Greystone patient leaped to his death.

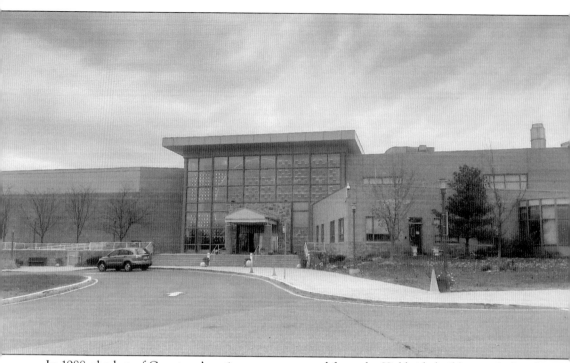

In 1988, the last of Greystone's patients were removed from the Kirkbride building and placed into smaller cottages on the grounds. Only the administrative offices remained in the building, operating entirely out of the center portion, while the serpentine ward wings that stretched out to the north and south sat disused. Administration utilized the Kirkbride until 2008, when a new $170 million hospital was opened on a hilltop to the northwest, directly behind the old asylum. The newly completed facility, also called the Greystone Park Psychiatric Hospital, had a ribbon-cutting ceremony complete with a release of doves on November 1, 2007. However, the doors of the new hospital remained closed to patients until July 16 of the following year. That same year, the clinic and Curry buildings were demolished, leaving the Kirkbride alone and abandoned. It remained this way for years, until it once again found itself in the center of a political storm and the media spotlight. This time, though, the public was not in an uproar over its hatred of the asylum—it was trying to save it. (Photograph by Christina Mathews.)

Four

GREYSTONE'S LAST STAND

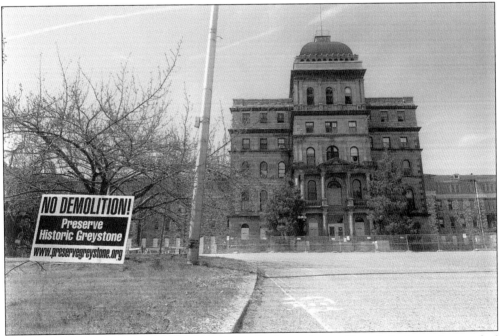

Greystone began its life as a monument of caring for those who could not help themselves, crafted for the betterment of society by those who put the wellbeing of others before their own. What could not have been foreseen then was that this same building would end its days as a nearly universally disliked facility, which bore witness to some of humanities' darkest deeds. In spite of that, during the years of Greystone's abandonment, a preservation effort was born. In time, what began as a quiet rumble to save beautiful buildings grew to be a groundswell that was felt across the country. (Photograph by Rusty Tagliareni.)

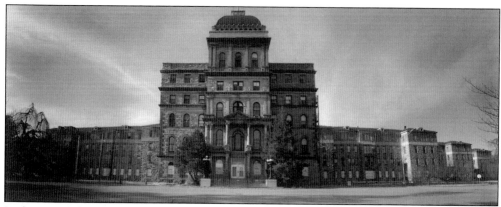

In the years following the demolition of Greystone's outbuildings, the land came to be rechristened as the Central Park of Morris County. The park featured soccer fields, cross-country paths, an ice-skating rink, and various other amenities. However, the redevelopment did little to distract from the fact that this was indeed the former grounds of a very large mental institution, as all the while Greystone's vacant Kirkbride building stood at the edge of the property. (Photograph by Mark Moran, Weird NJ.com.)

In 2008, as Greystone's Kirkbride building was being shuttered and the offices relocated, a nonprofit group formed to spread public awareness and to act as a way for citizens to foster a public discussion with the state as to the fate of the former asylum. They called themselves Preserve Greystone. Pres. John Huebner explained the purpose behind the formation of the group: "We saw something really big, and really important, falling through the cracks. . . . Preserve Greystone was formed when the Kirkbride was abandoned. The State had started making gestures in the direction of selling the property to a developer (and not the preservation kind of developer) and local officials banded together to put a stop to that." (Courtesy of Preserve Greystone.)

102

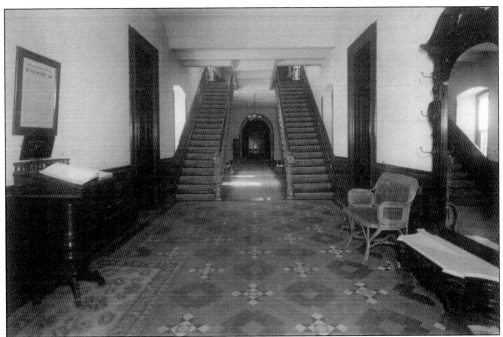

Huebner said that Greystone "was very well known to people in the area, but not at all well considered, and by that I mean that people didn't give it much thought—it was ever present, but on the fringes of the community's consciousness. Some people were frightened by it, but aside from the preservationists and the people who had some direct connection to it, most people weren't sure what to think about it. . . . But they were curious." (Above, courtesy of the collections of the North Jersey History Center, the Morristown and Morris Township Library; below, photograph by Rusty Tagliareni.)

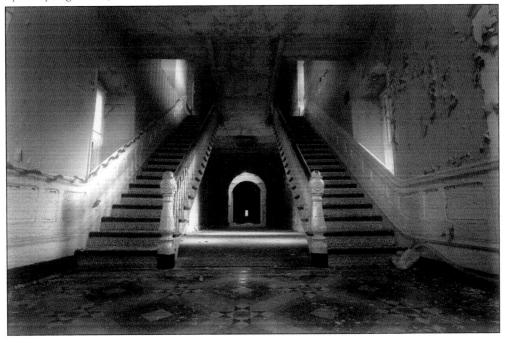

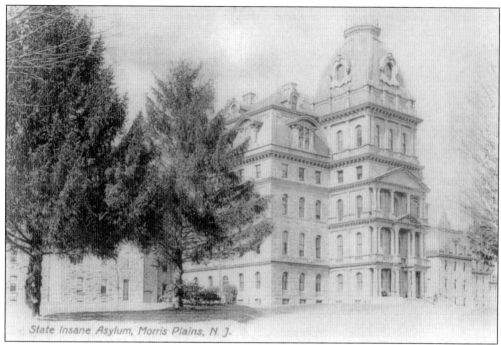

State Insane Asylum, Morris Plains, N. J.

The 1910 postcard above was one of the historical images used by Preserve Greystone to raise awareness of the site. As Huebner explains, "We went out and showed [the public] pictures, and taught them the history, and they ate it up. We stressed that it was still public property, and offered up the notion of redemption as an alternative to condemnation, and the response was overwhelmingly positive. Favorable vs. negative opinions towards adaptive re-use among the general public ran a remarkably consistent 98% throughout our advocacy." Below, a 2015 photograph shows the same view. (Above, courtesy of the Morris Plains Museum; below, photograph by Rusty Tagliareni.)

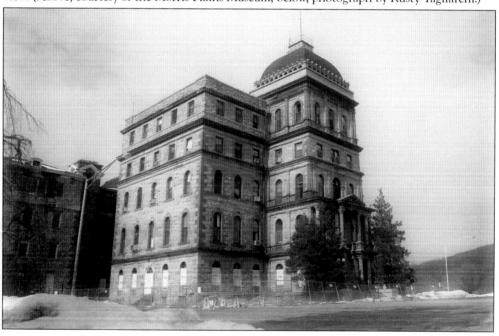

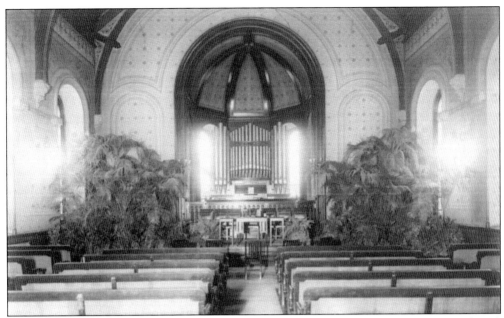

The preservation effort took years to build up steam. During that time, Greystone sat abandoned, left in a limbo between rehabilitation and demolition. The old chapel, pictured above in 1906, once a place of countless gatherings, sat in a heavy silence only occasionally disturbed by the sounds of nearby children playing in the park or a wild animal passing through. Though electricity no longer ran through the ceiling lamps, natural sunlight bathed the room in color every day through the stained-glass windows. Slowly, local news and social media began to pay more and more attention to the disused hospital and to the fight to save it. By 2014, updates on the old asylum were inescapable, with news of Preserve Greystone's fight reaching far across state lines and even overseas. Still, the halls, wards, and chapel of Greystone sat silent, awaiting a fate yet decided. (Above, courtesy of Pete Olin; below, photograph by Christina Mathews.)

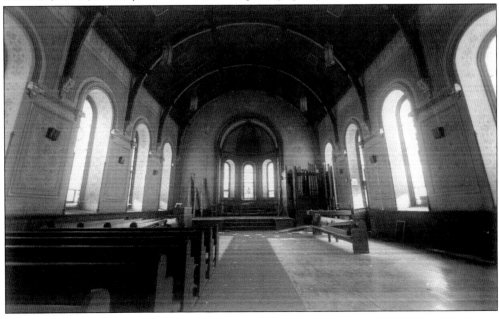

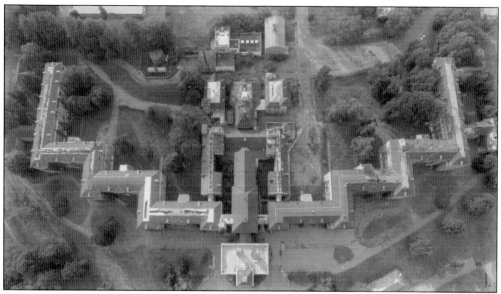

If there was a single point in time that can be identified as the fuel for what would become the groundswell of preservation support that rose in Greystone's final year, it would unquestionably be the moment New Jersey offered to hear out redevelopment plans for the Kirkbride building and then quickly dismissed every proposal it received. John Huebner explains: "By keeping [the proposals] secret until they announced that none of them were any good, the State deliberately robbed the taxpayers of the opportunity to consider the merits of the private expressions of interest. Furthermore, the State disingenuously framed their negative assessment of the private expressions of interest in fiscal terms, knowing that people would interpret this as 'it would cost too much,' but they never actually said that it would cost the State too much. They were saying it would cost the developers too much, an assessment that the developers clearly, publicly and repeatedly contradicted." (Photograph by Jim Phifer.)

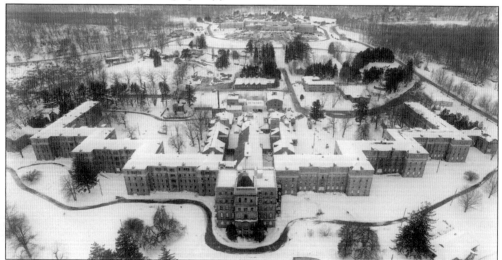

Pictured is Greystone during its final winter. Abatement of hazardous materials from the building had already begun at this point, in preparation for the spring demolition. The gray facade of the building, surrounded by a landscape of white, created a somber and nearly colorless vista. (Photograph by Mark Schey and Christian Garibaldi.)

John Huebner addresses the public at a press conference in front of Greystone. The primary topics were the numerous rehabilitation proposals that were rejected by the state, the lack of a public forum in which issues regarding Greystone could be addressed, and the $34.4 million bond that the state issued to cover the costs of the proposed demolition. Huebner stated, "Our state's transparency and open public records statutes are very weak, and this [Chris Christie] administration in particular has been blatantly, shamelessly opaque." (Both, photographs by Rusty Tagliareni.)

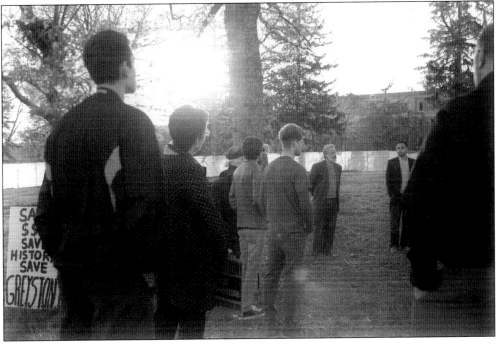

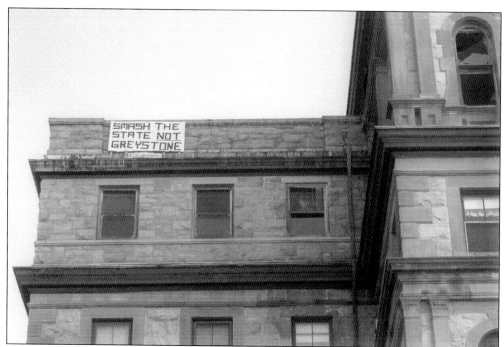

On the morning of April 6, the date on which the demolition of Greystone was to begin, the light of early morning revealed a banner hanging from the Kirkbride building's roof. Put in place by an unknown person at some point before dawn, it read, "Smash the State, not Greystone." As the sun rose, and the morning commute began to flow through the grounds, many people stopped to take photographs of the scene. The banner appeared in both local and statewide news and went on to be viewed as a symbol of the public's growing anger with the state of affairs at Greystone. (Both, courtesy of AbandonedNJ.com.)

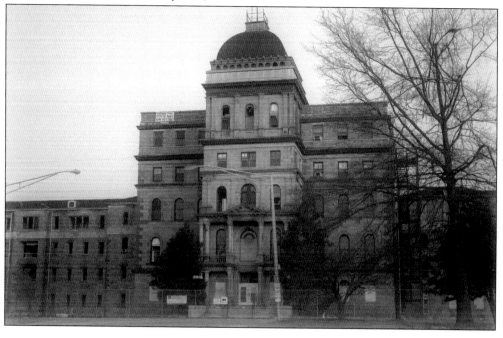

Days after demolition began on the Kirkbride building, members of Preserve Greystone, accompanied by numerous supporters, with ages ranging from senior citizens to teenagers, attended a Morris County freeholders meeting in an attempt to halt demolition. Sean Congdon, a resident of West Orange, New Jersey, addressed the freeholders, saying, "I work fifty-five hours a week, and there are very few things that can get me to come to a freeholders meeting for a county that I don't even live in, but this issue got me here in a heartbeat." After every address was met with silence from the freeholders, a Morris County resident named Charles Irwin stepped up to the podium and asked two questions: "Do you realize that the demolition of Greystone is irreversible?" and "What do you plan to do about the demolition?" He then surrendered his remaining time to the freeholders for response. They remained silent, as they would for the duration of the entire event. Toward the end of the evening, Nicholas Platt, the mayor of Harding Township, addressed the freeholders: "I came tonight just to observe and listen, but I think it would be very difficult to drive home tonight and think that I didn't say something." He then went on to compare the demolition of Greystone to the razing of Penn Station in 1963: "To this day everyone regrets it, and I think this may be the situation with Greystone." (Both, courtesy of William Westhoven, *Daily Record*.)

Harding Mayor Nicholas Platt

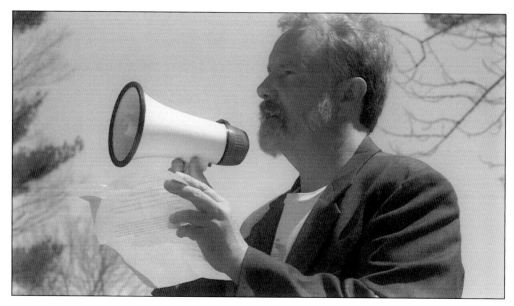

A rally was held on April 12, six days after demolition began on the outer wards of Greystone's southern wing. Called "Rally4Greystone," the event was put together in under a week, organized exclusively via social media channels, and took place without a permit from the Morris County Parks Commission. Preserve Greystone president John Huebner stood on a park bench to address those in attendance: "This is public money being spent on public land, and the public has every right to know what informed these decisions." Several hundred people were in attendance, and just like the freeholder meeting days prior, the ages of those participating ranged dramatically. People also came from many states away, with some from as far as Michigan. Those who traveled great distances to be present said they did it in hopes that it would help change the minds of those in power. (Above, photograph by Rob Moorhead; below, photograph by Rusty Tagliareni.)

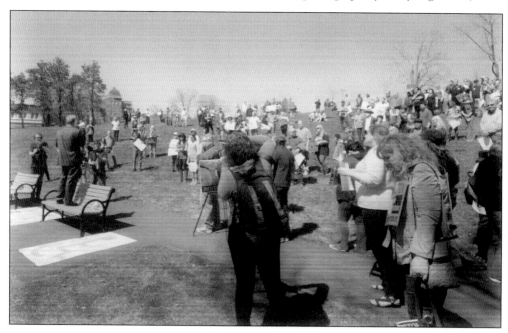

Grover Kemble (right) performs at the Greystone rally. "This Land is Your land" was heard often that day, echoing Woody Guthrie, who was a patient at Greystone from 1956 to 1961. Kemble's familiarity with the musical history of the old asylum is no coincidence; he worked as a music therapist at Greystone for 25 years, eventually retiring when the old buildings were shuttered and replaced by the new facility up the hill. (Photograph by Ray Staten)

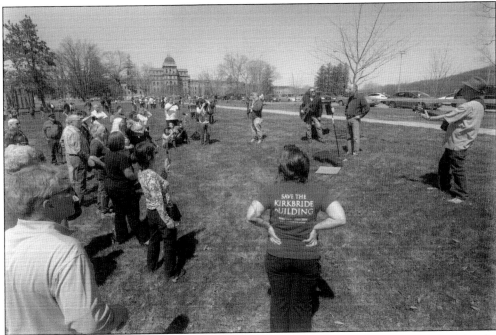

Grover Kemble, surrounded by rally-goers, plays an original song he wrote inspired by the preservation efforts. Titled "They're Trying to Tear Ol' Greystone Down," it became the unofficial theme of the event and the efforts of preservationists: "They're trying to tear Greystone down. / They're trying to tear it down to the ground. / Many lost soul has been found, / So please don't let them tear ol' Greystone down." (Photograph by Rusty Tagliareni.)

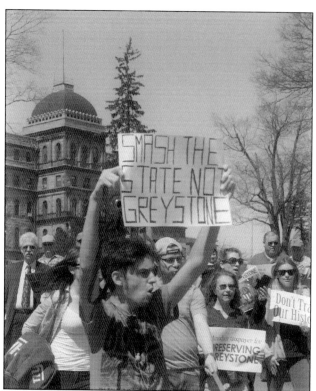

The scene perfectly matched lyrics written by Grover Kemble: "The senators and legislators are letting us all down, / they're saying that it's not worth the price. / They're cryin' to us folks that they've got to use the land, / but what is sacred shelter to sacrifice? / And the stories of compassion there abound. / A monument of caring so profound. / Those hallowed halls of refuge will astound. / And the ghost of Guthrie's spirit can be found. / The wrecking ball's a timepiece tightly wound. / So citizens please join the battleground." The rally culminated with hundreds of people marching up Central Avenue to Greystone's front steps, chanting "Don't tear it down!" (Left, photograph by Ray Staten; below, photograph by Rusty Tagliareni.)

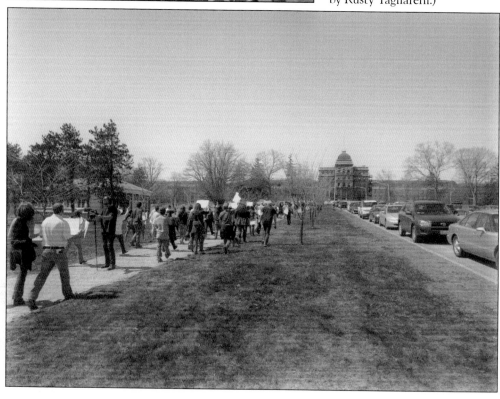

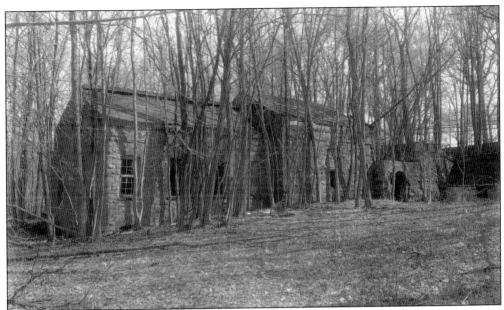

The rally, though covered extensively in local and state news, did not result in a stay of demolition for the old asylum. The speed at which the state was allowed to move forward was partly due to the fact that the Kirkbride building was not listed in the National Register of Historic Places, and therefore lacked any protection. Many preservationists were quick to point out that the old gasworks for the asylum, a building that now sits overgrown, abandoned, and decaying, was granted historic protection. They questioned why the protections granted to what amounts to ruins were not extended to the building that it was constructed to power—a building of considerably more historical significance. Still others wonder about the significance of the national register. (Above, photograph by Rusty Tagliareni; below, courtesy of VacantNewJersey.com.)

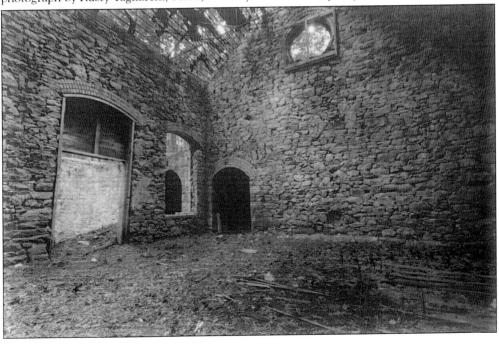

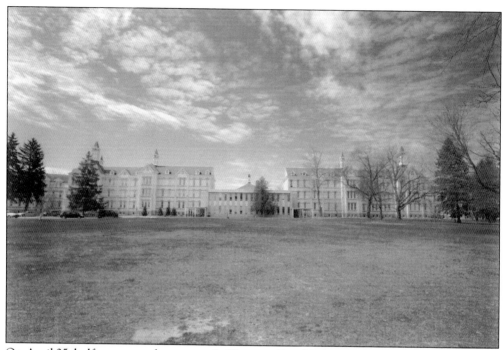

On April 25, halfway across the country in Traverse City, Michigan, the first PreservationWorks conference was held at the fully rehabilitated Traverse City State Hospital. A former Kirkbride plan asylum itself, it now goes by the title of the Village at Grand Traverse Commons. The purpose of the conference was to discuss national efforts to aid in preserving the last remaining Kirkbride plan asylums and to establish a nonprofit entity to coordinate such endeavors. (Photograph by Rusty Tagliareni.)

PreservationWorks founder and president Christian J. VanAntwerpen speaks to a crowd gathered in a courtyard of the former Traverse City State Hospital. This building, as well as the great success of its rehabilitation into a multiuse facility that includes residential units, commercial space, and an indoor public market, is often used as an example of the tremendous possibilities locked away in what some may see as just an old asylum. (Photograph by Crystal VanAntwerpen.)

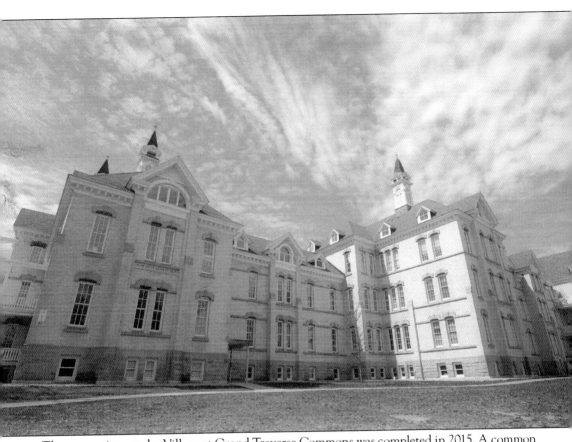

The renovations at the Village at Grand Traverse Commons was completed in 2015. A common topic from the conference dealt with the handling of this Michigan Kirkbride and the stark contrast with New Jersey's handling of Greystone, especially considering that the former Traverse City asylum was in arguably worse shape than Greystone before repairs were made. Christian J. VanAntwerpen explains the purpose of the newly founded PreservationWorks: "I was seeing preservation struggles at multiple locations (Fergus Falls and Greystone at that time) and thought if we could pool resources across the country, and get everybody under one roof, then maybe we could all work together to come up with solutions to help preservation efforts for multiple locations. The story of what was happening at Greystone had a profound impact on the establishment of the group." (Photograph by Rusty Tagliareni.)

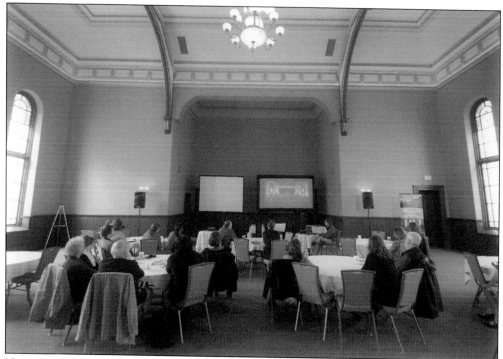

VanAntwerpen continued, "We plan to use the demolition of Greystone Park as a cautionary tale for use in future preservation efforts. We are encouraged that the public backlash is a less than subtle reminder to those with baseless plans to demolish these structures. It shows that people do indeed care about their history, and that these places matter." Here, in the former asylum's amusement hall and chapel room, people gather for a PreservationWorks conference. This grand chamber has come to be renamed Kirkbride Hall and hosts events such as wedding receptions and banquets. (Photograph by Rusty Tagliareni.)

Gene and Maxine Schmidt discuss the preservation efforts at the Kirkbride asylum in their hometown of Fergus Falls, Minnesota. They mentioned that the story of Greystone Park helped in their own efforts back home, with many using the phrase "Don't let this become another Greystone." Before Greystone's walls were even fully razed, it had already become an ominous warning on the lips of concerned citizens in a town over 1,300 miles away. (Photograph by Crystal VanAntwerpen.)

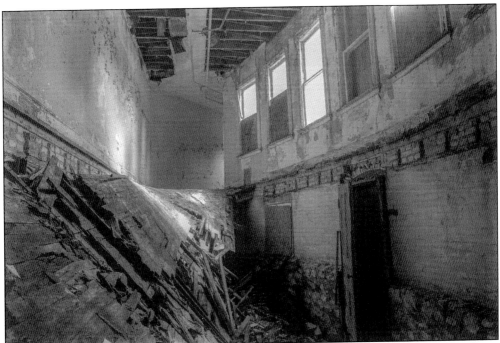

The former Traverse City State Hospital (above) had been left abandoned and badly weathered for a decade before Ray Minervini (pictured at right addressing the PreservationWorks conference) and his team the Minervini Group began rehabilitating the building. With some portions of the building suffering from partial collapse, Minervini explained that renovations were a long and difficult process, impended by many regulations that, at times, hindered the very efforts they are supposed to guide: "Sadly, the cards are stacked against preservation of Kirkbrides, and most other historic buildings. Those entrusted as the guardians of preservation tend to be much too rigid in their interpretation of the 'Standards' rather than embracing flexibility for adaptive reuse. (Above, photograph by Christian J. VanAntwerpen; right, photograph by Robert Kirkbride.)

Preserve Greystone made numerous requests to the State of New Jersey, under the Open Public Records Act, for release of information regarding the state's plans for the Greystone site. Eventually, the group hired an attorney to address the matter on their behalf. In turn, the state was forced to release paperwork to Preserve Greystone. However, it was so heavily redacted that little information could be gleaned from it. Pictured is a small sample of pages featuring heavy redaction. (Photograph by Rusty Tagliareni.)

In light of the impending demolition at Greystone, a grassroots group formed, headed by Robert Duffy of KirkbridesHD, in an effort to push the state and county for a more substantial monument than the one that was initially proposed and to aid wherever possible with the logistics and funding for such an undertaking. Called simply the Greystone Park Memorial, the concept is to recreate the front facade of the old asylum, utilizing ornate features preserved from the facility before its demolition. In doing so, visitors can experience the former Greystone facade. Elements such as columns, hand-carved limestone, and the stonework portico have been saved and placed safely aside for use in the proposed memorial. (Both, courtesy of Clara Daly.)

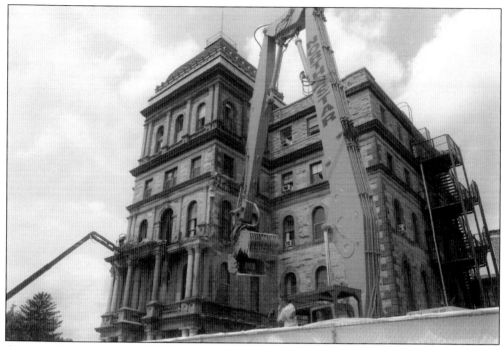

On July 6, 2015, key elements of Greystone's facade were delicately removed by members of the demolition company and placed aside to be incorporated into the future memorial. Great care was needed when removing the decorative stonework, as the pieces selected had been installed for some 130 years and were never meant to be removed. Some unavoidable damage did occur to some stonework, but plans have been made to repair and replicate any elements that were affected. (Above, photograph by Christina Mathews; below, photograph by Rusty Tagliareni.)

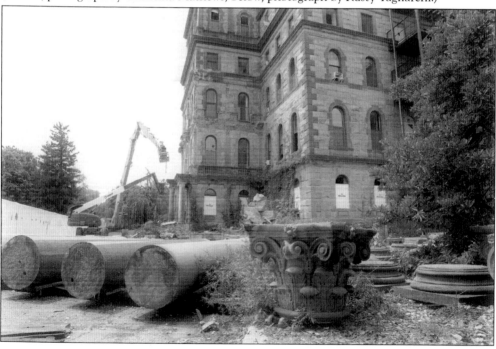

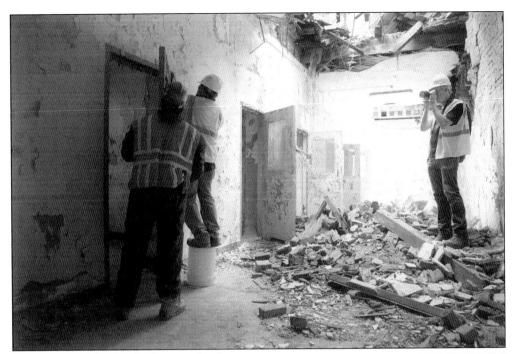

Beyond saving the facade elements for the future Greystone Park memorial, a door from Greystone's ward 40 was also removed prior to demolition. Though it may appear like any other door in the ward block, it marked where Woody Guthrie stayed when he was first admitted to Greystone. Above, Phil Buehler, author of *Woody Guthrie's Wardy Forty: Greystone Park State Hospital Revisited*, photographs the removal of the door by members of the demolition crew. After removal was complete, the door was shipped to the Woody Guthrie Center in Tulsa, Oklahoma, to become part of the museum's permanent exhibit chronicling Guthrie's time at Greystone. (Photograph by Rusty Tagliareni.)

As demolition progressed, passersby in the park would come to leave flowers on the fence erected in front of the old hospital. Though put in place to protect against debris scattering into the surrounding parkland, the temporary wall came to be a kind of impromptu memorial, with trinkets and occasional notes being deposited on it. (Photograph by Rusty Tagliareni.)

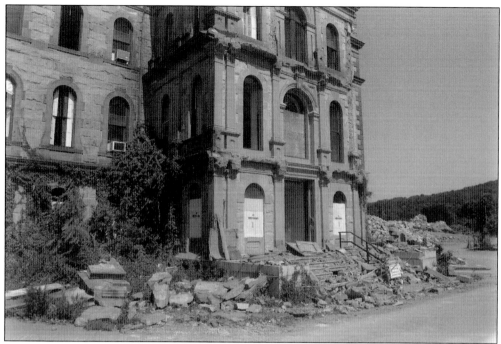

As demolition proceeded and the building's ornate stonework was removed, Greystone became less and less recognizable. Seen here toward the end of work on the site, it was difficult to fathom that this grimy mess of stone and brick was once one of the most celebrated hospitals in the country. Still, looking hard enough, glimpses of what once was were still visible. (Above, photograph by Lisa Marie Blohm; below, courtesy of Pete Olin.)

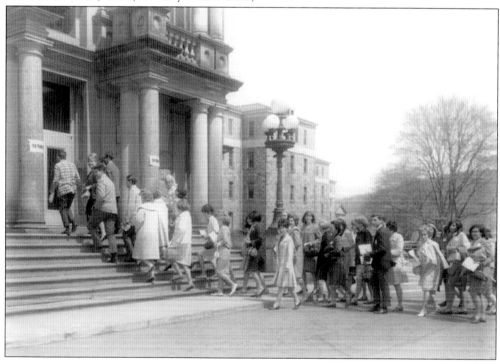

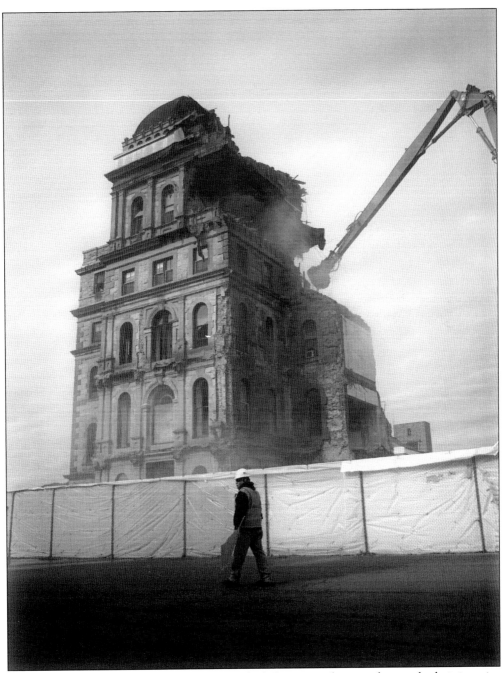

On October 14, 2015, demolition finally reached the iconic dome and central administrative portion of Greystone asylum. This portion of the building was in structurally sound condition, having only been vacated in 2008. As work progressed, portions of stonework toppled in large pieces, the ground trembling as each hit the earth. Moans frequently emanated from the building as metal supports bent and failed under the pressure of the demolition equipment. A man watching from the sidewalk commented, "Years ago the patients cried out from inside. Now the building itself screams." (Photograph by Rusty Tagliareni.)

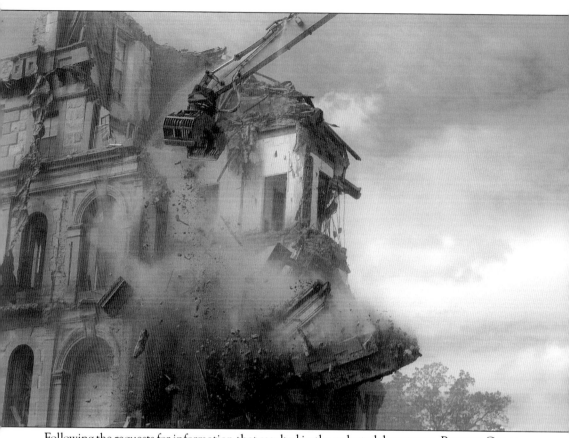

Following the requests for information that resulted in the redacted documents, Preserve Greystone submitted additional appeals to halt demolition until the application for Greystone to be listed as a National Historic Place could be reviewed. The court would not grant an emergent hearing on the appeal, stating that the building was not in imminent danger. Greystone fell while the appeal was still pending a hearing. (Photograph by Rusty Tagliareni.)

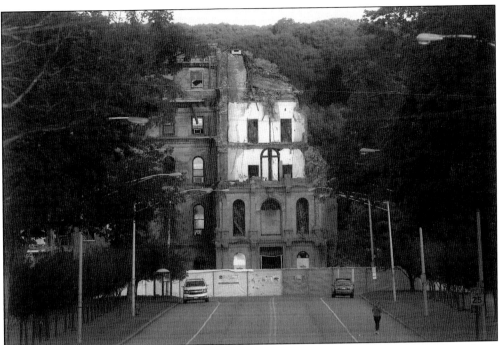

During the demolition of Greystone's administration building, the slow approach to the asylum's front steps, which used to welcome drivers coming up Central Avenue, was instead replaced by a surreal sight of jagged edges and ever-crumbling stonework. At times the sound of demolition equipment and the nearby children's soccer games mixed to create an otherworldly soundscape to match the spectacle. (Photograph by Bob Karp, *Daily Record*.)

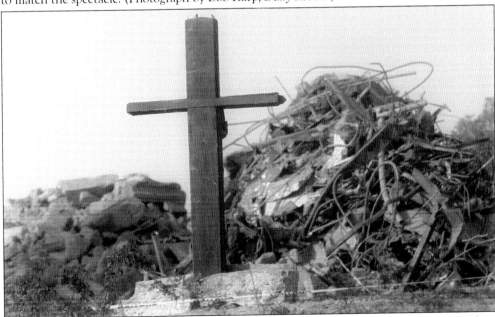

When Greystone finally fell, workers on the site erected a memorial in the asylum's footprint from pieces of debris. It served as a poignant reminder that even those working here understood what this building meant and how people felt regarding its loss. (Photograph by Bob Karp, *Daily Record*.)

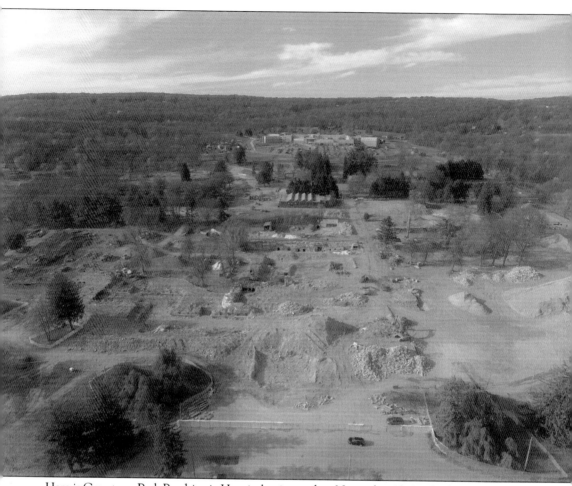

Here is Greystone Park Psychiatric Hospital as it stood on November 12, 2015. The nation's largest Kirkbride asylum was little more than mounds of dust and stone. As it was raised from the earth in 1876, so it returned, ground up with machinery to become backfill, which eventually will be leveled out and seeded with grass. In time the grass will grow, and in time generations will pass. One day, it will be impossible to tell that this open plot of land once housed one of our nation's proudest and most influential mental institutions. (Photograph by Jody Johnson, GlideByJJ.)

The final entry in *Rhymes of a Raver* is a piece titled "And Last." It speaks of leaving Greystone and returning to life after having been bettered by the asylum. It seems appropriate that we close this book the same way. (Courtesy of the Morris Plains Museum.)

And Last

Now my rhymes are finished,
I send this book of blue
Out amongst you mortals
And hope I've brought to you

An hour or so of pleasure:
And given a little time
Of interest and forgetfulness
With these crude rambling rhymes.

And in this rhyme rough-metred
I'm bidding you good-bye,
I'm leaving dear old Greystone,
Once more with Fate to vie.

I'm going out into the world;
The doctors say I'm well.
Oh, what a gloried message
A broken one to tell.

I'm going to the work I love,
To doctor ailing trees,
To garb drab hills with foliage
And cool the summer's breeze.

I'm going to swing my sweating lads
On through a marble hill.
And listen to the grind of gears,
And song of sledge and drill.

I'm going back to making dams
And building great, wide parks,
Where humans tired of city's din
May hear the trill of larks.

DISCOVER THOUSANDS OF LOCAL HISTORY BOOKS
FEATURING MILLIONS OF VINTAGE IMAGES

Arcadia Publishing, the leading local history publisher in the United States, is committed to making history accessible and meaningful through publishing books that celebrate and preserve the heritage of America's people and places.

Find more books like this at
www.arcadiapublishing.com

Search for your hometown history, your old stomping grounds, and even your favorite sports team.

Consistent with our mission to preserve history on a local level, this book was printed in South Carolina on American-made paper and manufactured entirely in the United States. Products carrying the accredited Forest Stewardship Council (FSC) label are printed on 100 percent FSC-certified paper.

MADE IN THE